IMAGES
of America

MEXICAN AMERICANS OF WICHITA'S NORTH END

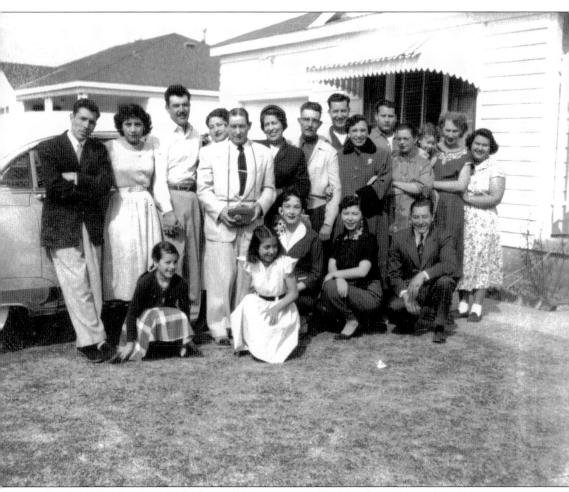

By the 1950s, families who had started their stories in Wichita along Twenty-First Street were now looking to move to suburban, middle-class lives. Pictured here from left to right are (first row) Dolores "Lola" Roman, Sandra Roman, Sally Roman, Amelia "Tillie" Roman, and Pete Roman; (second row) Arthur Martinez, Virginia Roman, Joe Roman Jr., Maria Roman Ornelas, Felix Meza, Juanita Meza, José A. Roman, Alfonso "Al" Roman, Andrea Roman, Robert Ornelas, Anna Ornelas, Rene Roman (baby), Babe Roman, and Grace Ornelas. (Courtesy Caroline Ornelas Kelley.)

ON THE COVER: Some Cudahy workers have lunch at the local restaurant Chata's. The owner, Aurelia "Chata" Ornelas, is on the far left. Since this was a weekday lunch crowd, they probably were eating hamburgers or a bowl of chili because China's famous menudo was only available on weekends. (Courtesy Vicki Guzman Cruz.)

IMAGES
of America

MEXICAN AMERICANS OF WICHITA'S NORTH END

Anita Mendoza, José Enrique Navarro,
and Jay M. Price

ARCADIA
PUBLISHING

Published by Arcadia Publishing
Charleston, South Carolina

Printed in the United States of America

Library of Congress Control Number: 2021950610

For all general information, please contact Arcadia Publishing:
Telephone 843-853-2070
Fax 843-853-0044
E-mail sales@arcadiapublishing.com
For customer service and orders:
Toll-Free 1-888-313-2665

Visit us on the Internet at www.arcadiapublishing.com

This book is dedicated to the immigrants who sacrificed so much to create new lives in the heart of the country and who reminded the next generations to "never forget where you came from."

CONTENTS

ACKNOWLEDGMENTS

Book projects such as this draw on a wide range of sources. The team wants to thank Empower Evergreen; First Presbyterian Church; Hewitt's Antiques; La Familia Senior and Community Center; Library of Congress; KPTS; KMUW; Migrant Kitchens Project; Kansas Aviation Museum; Kansas Historical Society; LatinFest ICT; McCormick School Museum; Municipal Archives of Tepatitlán de Morelos: Radio Lobo; Wichita Art Museum; the *Wichita Eagle*; Wichita Hispanic Chamber of Commerce; Wichita Public Library; City of Wichita Planning Department; Wichita–Sedgwick County Historical Museum; Wichita–Sedgwick County Metropolitan Area Planning Department; Wichita Parks and Recreation; Wichita Police Department; Wichita State University Office for Workforce, Professional, and Community Education; Wichita State University Libraries, Special Collections and University Archives; and Wichita State University Society of Public Historians. Funding for this project came from grants from Humanities Kansas and Wichita State University (WSU). Thanks go to Our Lady of Perpetual Help, the Wichita State University Community Education Program, and Sweet P's and other scanning locations. Thanks to the many WSU students who helped collect information, scan photographs, translate materials, and conduct interviews for the project, including Valeria Adame, Logan Daugherty, Kaitlyn Eddins, Darlajean Gilbert, Brittany Herod, Hayley Lyda, Carolina Loera, Cinthia Lopez, Vinh Nguyen, Joshua Mackey, Anthony Seiler, Ryan Thomas, and Suzanne Walenta. The team also appreciates the help of those in the community who assisted with photographs and other materials, including Frank Acevedo, Marco Alcocer, Chris Alonzo, Russ Armitage, Cinthia Ornelas Avilar, Seth Bate, Carolyn Benitez, Elizabeth Brunscheen-Cartagena, Yolanda Camarena, Gene Chavez, Marcelino Chavez, Robert Chavez Jr., Cindy Claycomb, Cornejo Construction, Don Cruz, Paul Cruz, Vicki Guzman Cruz, B.J. and Jonell Davies, Rocío del Aguila, David Dinell, Ramón del Castillo, Steve DelCastillo, Janiece Baum Dixon, Todd and Lisa Duran, Carla Eckels, Michelle Enke, Victoria Estrada, Brandon Findley, Adele Garcia, Delia Garcia, Marie Garcia, Magda Garrett, Bill Goffrier, Jim Grawe, Jim Hernandez, David Hughes, Gary Huffman, Caroline Kelley, Juanita Lepe, Tony Madrigal, Guadalupe Magdaleno, Angela Martinez, Daniel "Bubba" Martinez, Jim Mason, Mike Maxton, Charles McAfee, Mark McCormick, Jeanne Mendoza, David McGuire, Brenda Ornelas McKellips, Rachelle Meinecke, Janet Miller, Armando Minjarez, Vicki Monarez-Malter, Teresa Mora, Kathy Morgan, Bobby Murguia, Helen Navarete, Mary Nelson, Leticia Nielsen, Paul Oberg, Raymond Olais, Natalie Castro Olmsted, Amelia "Tillie" Roman Ornelas, Caroline Ornelas Kelley, Mac Orsbon, Tirso Ortiz, Connie Palacioz, Robert Reyes, Michael Masias Rivers, Ariel Rodriguez, Joe Rodriguez, Archie Roman, Eli Romero, Ray Romero, Carmen Rosales, Mike Rosales, Ron Rosales, Rosalie Rosales de Lopez, Randy Roths, John Sanchez, David Sandoval, Linda and Lydia Santiago, Mickey Sheaks, Susan Angulo Stallings, Dee Starkey, Linda Stoner, Jami Frazier Tracy, Veronica Triana, Dave Ulrich, Felicia Urbina, Frances Vanderhoff, Israel Villa, Matt Williams, Alberto Wilson III, and Keith Wondra. All photographs not attributed are courtesy of the members of the Somos de Wichita team.

The project team regrets that not all images donated could be used. The team also regrets that significant persons, events, and institutions did not get covered in as much detail as they deserve. We hope, however, that this book will inspire others to work to tell these and other stories as well as donate and preserve memories, records, and photographs to ensure that future generations know the Mexican American story of Wichita. For more information, please visit somos.wichita.edu (and thanks to Mike Marlett for helping us set that up amid a pandemic), WSU Special Collections, and the Facebook page for the North End Wichita Historical Society.

INTRODUCTION

Look at various maps of North Wichita, and it becomes apparent that the neighborhoods around Twenty-First Street get called by many names. Sometimes it is Nomar. Sometimes it is El Pueblo, La Veintiuno, or El Huarache. For most locals, it is simply the North End. Today, Wichitans associate this part of town with being the heart of the Mexican American community. The association is so strong that many do not realize that there are Mexican Americans in other parts of the city. Many do not realize that the North End has always been a multicultural space, the home for people from many backgrounds.

It was here, between Chisholm Creek and the tracks, that became Wichita's hub for grain elevators, warehouses, the Dold and Cudahy packinghouses, and eventually, a refinery. Workers in those industries lived nearby, in modest frame homes. By the 1920s, it was also on one of North America's early north-south highways.

Telling the story of such a dynamic and complicated place is challenging. It is, however, the story of families who immigrated from Mexico that represents perhaps the most distinctive window into how the neighborhood has changed. They began working for the railroads, living in converted boxcars and modest frame buildings. Later on, as the packinghouses provided a solid source of income, families settled to create institutions, churches, and other connections. Their children grew up, went to school, played sports, and married and had children of their own. Some stayed in the North End. Others moved to other parts of the city or even farther away. The North End as an industrial center faded in the 1970s as the packinghouses moved, the stockyards, elevators, and refinery closed, and Interstate 135 replaced Broadway as the main north-south artery through Wichita. The area fell on hard times. In part because of the inexpensive housing, new immigrant families moved in. The area once again became a place of opportunity. This time, the arrivals were immigrants from Mexico and other parts of Latin America who established their own traditions and institutions. What follows, then, is the story of how Wichita's northern end developed from an industrial area into a place now known for its Mexican restaurants and shops that sell items for quinceañeras.

A few years ago, the North End Wichita Historical Society was formed to preserve the history of this part of Wichita. It has hosted collecting efforts that include the images in this book. It has hosted digital exhibits such as the website somos.wichita.edu. Its Facebook page has been the setting for many lively conversations. The society hopes that this work inspires other parts of the North End's many voices to continue the conversation.

Introducción

Si mira varios mapas del norte de Wichita, verá que los vecindarios cerca de la Calle 21 reciben muchos nombres. Unas veces es Nomar. Otras es El Pueblo, La Veintiuno, o El Huarache. Para la mayoría de los que viven allí, es simplemente el North End. Hoy, los habitantes de Wichita relacionan esta parte de la ciudad con el corazón de la comunidad mexicoamericana. La asociación es tan fuerte que muchos no se dan cuenta de que hay mexicoamericanos en otras partes de la ciudad, y de que el North End siempre ha sido un espacio multicultural, el hogar de personas de diferentes orígenes.

Este lugar, situado entre Chisholm Creek y las vías del tren, se convirtió en el eje de Wichita gracias a los elevadores de granos, los almacenes, las empacadoras Dold y Cudahy y, ultimadamente, una refinería. Los trabajadores de esas industrias vivían cerca, en casas modestas. En la década de 1920, también se construyó allí una de las primeras carreteras que cruzaba los Estados Unidos de norte a sur.

Contar la historia de un lugar tan dinámico y complicado es un desafío. Sin embargo, es quizás la historia de las familias que emigraron de México la que representa mejor cómo ha cambiado el vecindario. Comenzaron a trabajar para los ferrocarriles, viviendo en vagones convertidos y modestos edificios de estructura de madera. Más tarde, cuando las empacadoras proporcionaron una fuente estable de ingresos, las familias se establecieron y crearon instituciones, iglesias, y otros vínculos. Sus hijos crecieron, fueron a la escuela, practicaron deportes, se casaron y tuvieron sus propios hijos. Algunos se quedaron en el North End. Otros se mudaron a otras partes de la ciudad o incluso más lejos. Como centro industrial, el North End se desvaneció en la década de 1970 cuando las plantas de empaque se trasladaron a otras ciudades, los corrales cerraron, los ascensores y la refinería desaparecieron, y la carretera Interstate 135 reemplazó a Broadway como la principal arteria norte-sur que cruzaba Wichita. La zona vivió tiempos difíciles. Debido en parte a las viviendas económicas, nuevas familias de inmigrantes se instalaron en el barrio. El área se convirtió una vez más en un lugar de oportunidades. Esta vez, los que se establecieron fueron emigrantes de México y otras partes de América Latina que instauraron sus propias tradiciones e instituciones. Por tanto, lo que describen las páginas de este libro es la historia de cómo el extremo norte de Wichita pasó de ser una zona industrial a un lugar ahora conocido por sus restaurantes mexicanos y tiendas que venden artículos para quinceañeras.

La Sociedad Histórica del North End de Wichita se fundó hace unos años con el objetivo de preservar la historia de esta zona de Wichita. Algunas de las imágenes recogidas en este libro fueron recopiladas en encuentros organizados por la sociedad. Asimismo, ha acogido exposiciones digitales como el proyecto somos.wichita.edu. Su página de Facebook ha sido testigo de muchas conversaciones animadas. La Sociedad espera que este trabajo inspire a otras de las muchas voces que componen el North End a continuar la conversación.

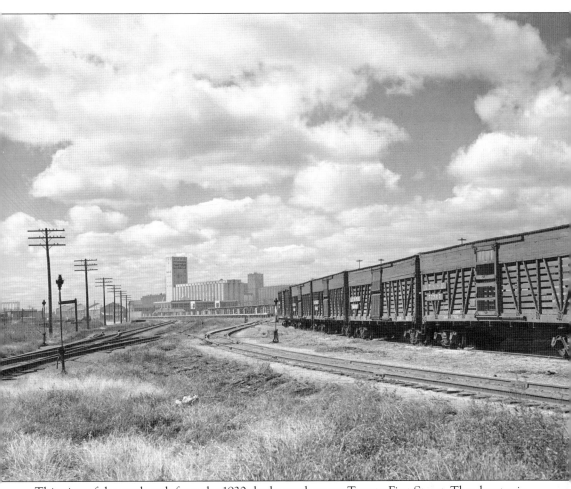

This view of the stockyards from the 1930s looks south across Twenty-First Street. The elevator in the background, with the Pillsbury advertising, is adjacent to the Mexican American community of El Huarache. (Courtesy Library of Congress.)

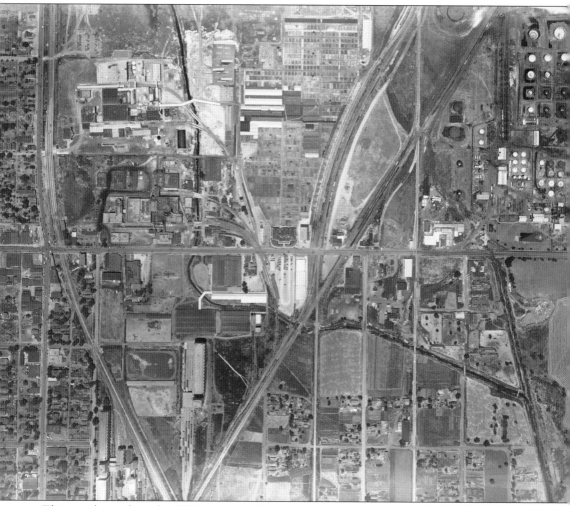

This aerial view from the 1930s shows the North End as the city's industrial hub. The main east-west street is Twenty-First Street. In the lower right is what remains of Chisholm Creek, which has been transformed into a drainage canal for the stockyards and packinghouses. Throughout were neighborhoods where workers lived, among them Mexican American families. (Courtesy Kansas Aviation Museum.)

One

THE NORTH END

Initially, Wichita's industrial section was along the railroad tracks on the eastern edge of town. As the city grew in the 1880s, however, those industries moved to the north along the tracks between Seventeenth Street and Thirty-Seventh Street North, with Twenty-First Street becoming a key artery. This was the site of the new stockyards in the 1880s, followed by a string of packinghouses. By the early 1900s, grain elevators and mills began to be located here, followed by an oil refinery. This part of the city supported a diverse range of workers and their families. By the 1920s, stores, schools, and restaurants developed along Twenty-First Street between Chisholm Creek to the east and the Arkansas River to the west. Those who grew up in this part of Wichita still remember the stink from the stockyards and the refinery that permeated the air.

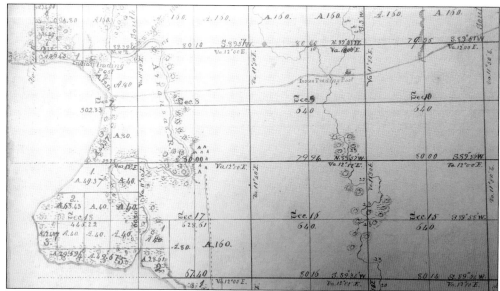

In 1867, a survey team marked off section grids in anticipation of expected settlement. Jesse Chisholm's homestead stood in the center of this map where a trade route crossed Chisholm Creek. Running from Towanda to a trading post on the Arkansas, the route runs diagonally between what is now Twenty-First and Seventeenth Streets. (Courtesy US Bureau of Land Management and Kansas Historical Society.)

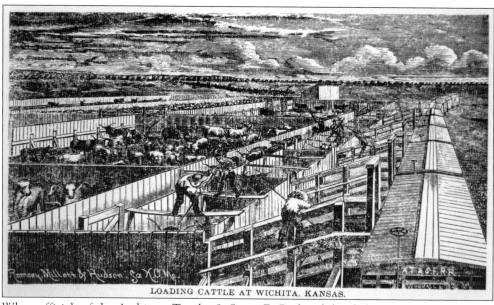

LOADING CATTLE AT WICHITA, KANSAS.

When officials of the Atchison, Topeka & Santa Fe Railroad decided to push their line from Newton due west, leaders of Wichita incorporated the Wichita & Southwestern Railroad to build a line that connected Wichita with the main line in Newton. Completed in 1872, this road enabled Wichita to become the main railhead for cattle drives coming up the Texas Cattle Trail. (Courtesy of the Kansas Historical Society.)

By the 1870s, Jesse Chisholm's trade route known as the Chisholm Trail became part of the larger Texas Cattle Trail that brought herds of Texas cattle to the railhead in Wichita. A number of the drovers/vaqueros who came up the trail were themselves of Mexican or mixed-race background, and newspapers often commented on Mexican and Mexican Americans drovers and their distinctive and colorful clothing. (Courtesy Gene Chavez.)

Mexican American drovers/vaqueros came with the herds and returned south when the herds were gone. The first Mexican families to actually settle down and live in Wichita did so adjacent to the railroad tracks near Douglas Avenue. Merchants like Cornelio Granado served these Mexican patrons. One of the first Mexican-oriented shops in Wichita was La Tienda de Don Cornelio at 405 South St. Francis Avenue, not far from where this photograph was taken. (Courtesy Wichita–Sedgwick County Historical Museum.)

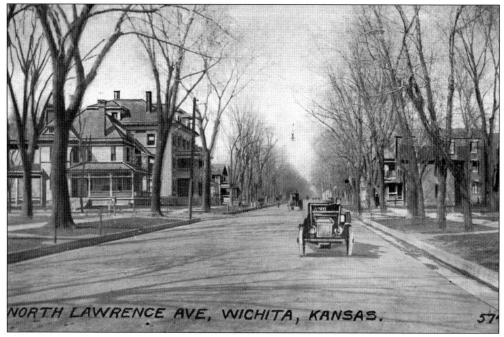

NORTH LAWRENCE AVE, WICHITA, KANSAS. 57

The cattle trail days ended in 1876 as the main cattle trails shifted west and Wichita rebranded itself as a respectable Victorian community. By the 1880s, developers established affluent neighborhoods on the city's edges. To the north of downtown, elegant homes extended along Waco Avenue, Market Street, Main Street, and Lawrence Avenue, the street that later became Broadway.

Nearby, housing for workers ranged from shotgun houses to what one newspaper article described as "cozy little cottages of the popular sizes." A five-room home was a "most satisfactory building that can be erected for any ordinary family." (Courtesy Linda Stoner.)

The North End has been diverse from its early years. One of the first developers was Jacob McAfee. In 1885, McAfee, a Civil War veteran, platted the McAfee Addition, which was north of Twenty-Fourth Street, just north of the land that became the stockyards and several meat-packing plants. (Courtesy Charles McAfee.)

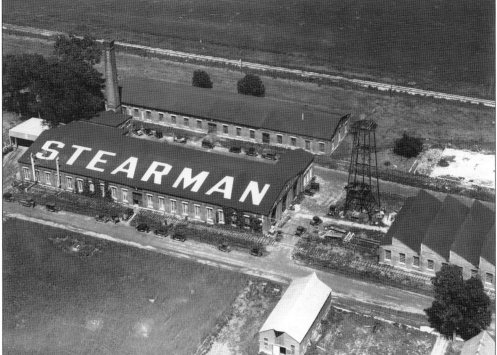

A short-lived venture intended to build railroad cars for racehorses, the Burton Stock Car Company facility on Thirty-Seventh Street later housed a broom corn warehouse, the John Jones automobile company, the first factory of aviation pioneer Clyde Cessna, and by the 1920s, Lloyd Stearman's aircraft company. The community of industries and worker housing that developed nearby became known as Bridgeport. (Courtesy Wichita–Sedgwick County Historical Society.)

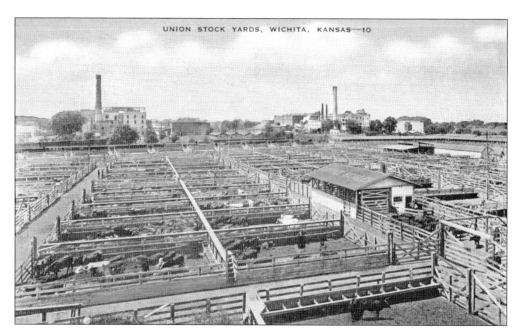

The original stockyards of Wichita were along the Santa Fe Railroad tracks near Douglas Avenue to receive cattle that streamed up on the Chisholm Trail. By the 1880s, the cattle trails were gone, replaced by cattle ranches. To handle this more regional cattle population in 1887, Wichitans opened new stockyards. The facility burned to the ground a day later. Rebuilt, the stockyards became a center of growth and development for the North End. (Below, courtesy Library of Congress.)

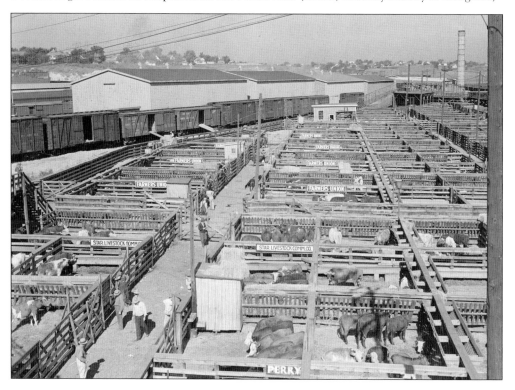

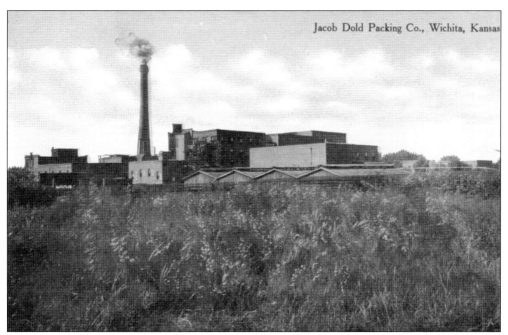

Jacob Dold Packing Co., Wichita, Kansas

Originally, stockyards loaded cattle to be taken to Kansas City or Chicago to be processed. In the late 1880s, however, Wichita business leaders brought in a branch of the Buffalo, New York–based Jacob Dold Packing Company. This Wichita branch was located at Twenty-First Street and Lawrence Avenue. During the 1890s, the Whittaker Packing Company constructed a facility adjacent to Dold that failed in the depression of the 1890s. In 1901, the area underwent a major transformation. A devastating fire at Dold prompted the company to rebuild with newer facilities, seen above. Meanwhile, a branch of the John Cudahy Packing Company, at the time based in Omaha, took over the Whittaker facility and redeveloped it. (Below, courtesy B.J. and Jonell Davies.)

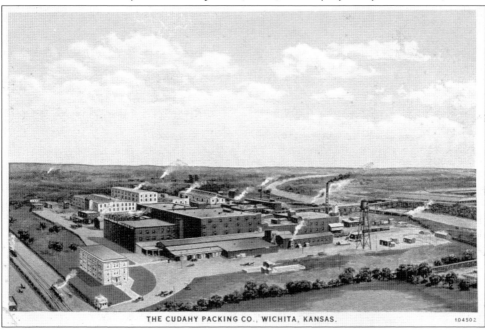

THE CUDAHY PACKING CO., WICHITA, KANSAS. 104502

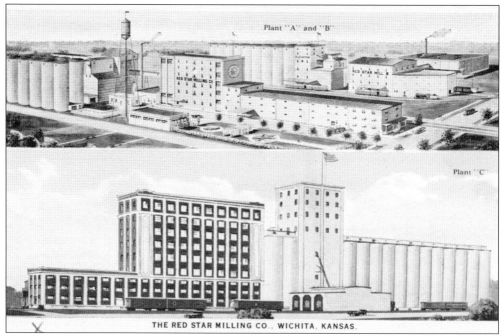

THE RED STAR MILLING CO., WICHITA, KANSAS.

Like the stockyards, the first grain elevators in Wichita were near Douglas Avenue along the railroad tracks. In the 1900s, however, north Wichita offered ample railroad access and more space for larger elevators. Among the first of the new facilities was the complex of the Red Star Mill and Elevator Company at Eighteenth Street and Emporia Avenue. Other elevators and mills soon followed.

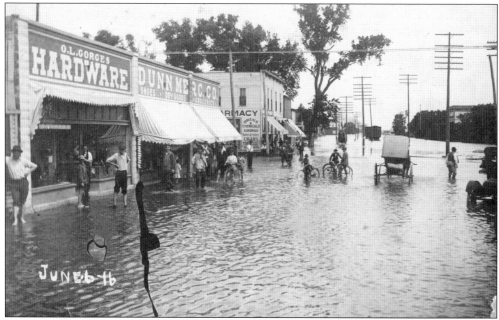

Both the Arkansas and Little Arkansas Rivers were prone to flooding. This scene is from a June 6, 1916, flood of the Little Arkansas. It was taken from Lawrence Avenue and Broadway looking north to Twenty-First Street. The Dunn Mercantile store No. 5 is on the southwest corner of the intersection. (Courtesy Jim Mason.)

Constructed in 1929, the Nomar Theater took its name from "North Market." Spanish Revival architecture was popular in theater design for the 1920s and was not a reflection of Mexican immigrant families in the vicinity. Early on, Mexican Americans were, like blacks, expected to sit in the balcony. (Courtesy Wichita–Sedgwick County Historical Museum.)

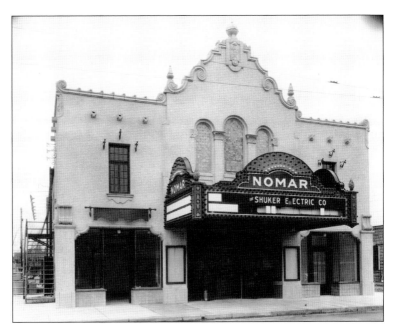

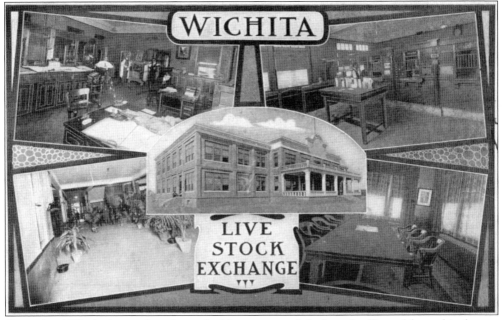

Opened in 1910, the livestock exchange building contained the branch offices of the packinghouses as well as those of several livestock commission firms, and the Wichita Terminal Railway Co. Decorations included a four-by-six-foot mosaic with the words "Market That Satisfies" surrounded by the heads of a cow, a horse, a pig, and a sheep. (Courtesy Jim Mason.)

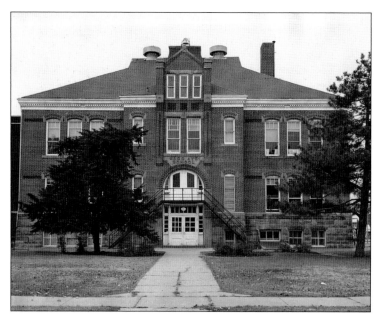

Families who moved into the North End needed schools for their children. One was Waco Elementary School, which opened in 1907. By the 1920s, Waco Elementary had 25 Mexican American students. In 1974, the school was closed and its pupils were accommodated in the new Cloud Elementary School. (Courtesy McCormick School Museum.)

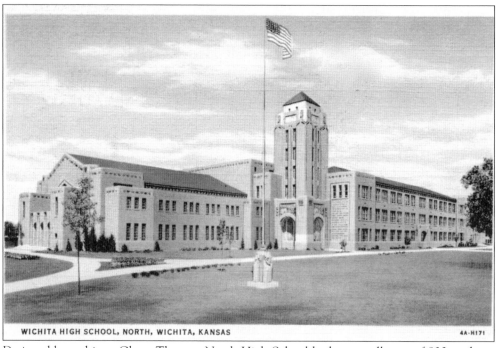

WICHITA HIGH SCHOOL, NORTH, WICHITA, KANSAS

Designed by architect Glenn Thomas, North High School had an enrollment of 800 students when it first opened its doors in 1929. Its construction was a response to the increasing number of students in Wichita's school system in the 1920s.

In 1911, the Kansas Good Roads Movement proposed a highway to extend from Canada to Mexico. By the 1920s, what became the International Meridian Road Association had developed this route that followed the Sixth Principal Meridian, eventually becoming US Highway 81. Hopes of the highway becoming part of a pan-American highway to extend down to Patagonia never materialized. (Courtesy Kansas Historical Society.)

By the 1920s, Lawrence Avenue had become part of US Highway 81 and transitioned from a prominent but local street into the primary thoroughfare for drivers through Wichita. In 1933, the city commission renamed the roadway Broadway Avenue, while gas stations, motor courts, and diners sprang up along the route. (Courtesy B.J. and Jonell Davies.)

THREE BLOCKS FROM THEATER AND SHOPPING DISTRICT

RANDEL GRILL

PLAZA CABIN COURT—WICHITA, KANS.—HIGHWAY 81—CITY'S FINEST—AIR CONDITIONED C-1000

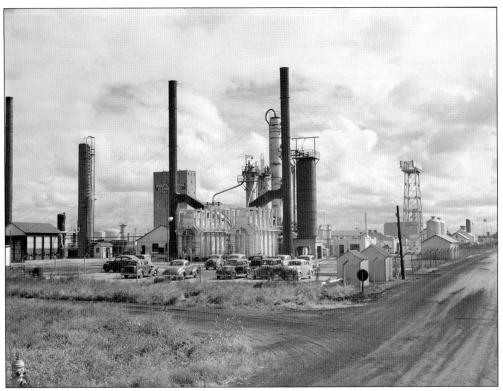

In the 1910s and 1920s, oil discoveries to the east and north of Wichita resulted in the construction of refineries in the area. In Wichita, a series of refineries emerged along Twenty-First Street, including the Western Refinery, the Derby Oil Company Refinery, and the K-T Refinery. (Courtesy Library of Congress.)

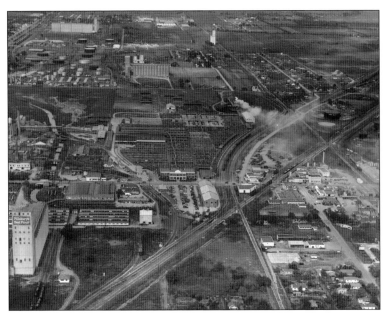

This aerial view of Twenty-First Street shows the stockyards and Livestock Exchange in the center. The Cudahy plant is at the left, with the Pillsbury elevator to the south. The Mexican American community of El Huarache is at lower right. (Courtesy Wichita–Sedgwick County Historical Museum.)

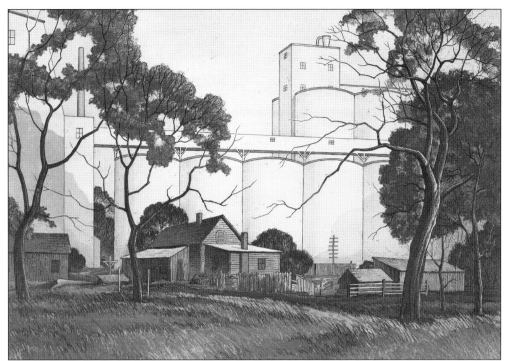

Two local artists who captured life in the North End were Charles "Chili" Capps and Edmund Davison. Capps's *Sunlit Towers* (above) and Davison's *The Junction* (below) saw the towering grain elevators as sculptural elements on the landscape while the rough homes of the workers nearby had their own aesthetic quality. (Above, courtesy Wichita Art Museum, gift of Mosby Lincoln Foundation; below, courtesy Edmund L. and Faye Davison Collection, Wichita Art Museum.)

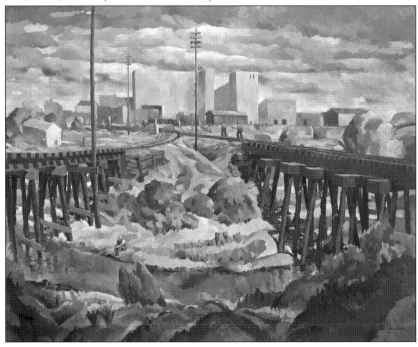

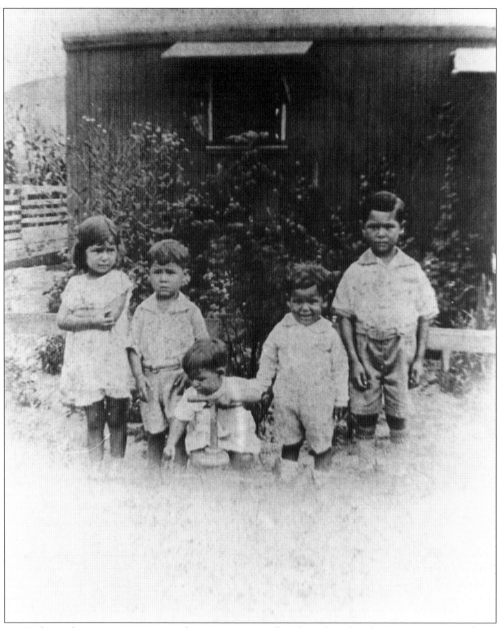

In Wichita, there were two areas where Mexican railroad workers lived. One was on South St. Francis Avenue. The other, seen here, was north of Cudahy, where housing included adapted rail cars. Here, the Navarro children stand outside their converted boxcar home in 1929. The toddler in the center, Augie Navarro, grew up to be one of Wichita's prominent golfers. (Courtesy Chris Alonzo.)

Two

EL HUARACHE, LA TOPEKA, AND THE "MEXICAN COLONY"

Between 1900 and 1910, railroads such as the Atchison, Topeka, & Santa Fe started to actively recruit Mexican laborers. At first, these were mainly seasonal workers whose meager wages were better than could be found back in the villages of Mexico. As economic conditions in Mexico deteriorated, revolution tore the country apart. Wichita's Mexican community still tells stories about the conflict. Hector Franco recalled that his father fought under Gen. Álvaro Obregón while his uncle was conscripted by Francisco "Pancho" Villa, an opponent of Obregón. Another member of the community, Don Rafael, was known to have supported federal forces and got his ears cut off by Pancho Villa as a warning. The Macias family tells the story of how patriarch Antonio had a small *ranchito* by La Piedad. When Pancho Villa tried to confiscate some horses, Antonio refused and had to flee to the safety of the United States.

Fleeing economic hardship and revolutionary instability, families joined these workers, establishing communities or barrios along the rail lines. These migrants came from a variety of places in Mexico. Railroad workers often came from places in the central Mexican plateau, such as Guanajuato, Michoacan, Zacatecas, Jalisco, and Aguascalientes. However, some families came from the northern Mexico area, such as Nuevo Leon and Chihuahua. Sometimes, families from the same town or village migrated to the same part of Kansas and maintained those ties in places like Wichita. Sometimes, however, families moved from place to place within the United States and came to Wichita after living for a time in places like California. Some stayed with the railroads, especially in places like Newton. In Wichita, workers often sought out more stable employment with the packinghouses and stockyards. They formed barrios or *colonias* across the city's northern industrial sector, the best known of which was El Huarache, or "the Sandal."

World War II changed things dramatically for Mexican Americans in the United States. Labor shortages in rural areas led to the creation of the Bracero program. In cities like Wichita, it was women who joined the workforce while the men were overseas. Military service was important for many families. After the war, these GIs were able to build new lives as well as organize for civil rights.

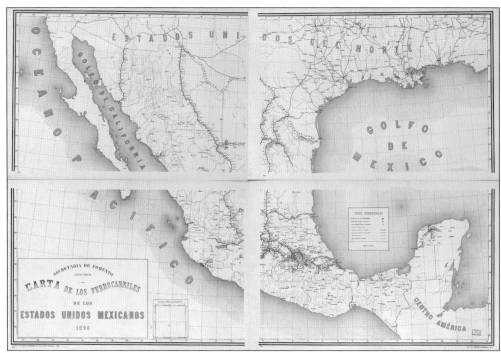

Families who arrived in Wichita came from a variety of states. The map above shows Mexico in the 1890s with railroad lines leading north to the United States. Many immigrant family stories followed these rail lines. Some, such as the Mendozas, were from northern states along the border. Families such as the Maciases came from La Piedad in Michoacan while the Rosaleses were from Guanajuato. Others, such as the Romeros, came from Tepatitlán in Jalisco, seen below. In honor of that town, the family of Felipe Lujano (today known for the Felipe's chain) named their first restaurant Tepas. (Above, courtesy Library of Congress; below, courtesy of Municipal Archives of Tepatitlán de Morelos.)

The first Mexican Americans in Wichita came with the railroad and lived along the tracks close to Kellogg. A newspaper article mentioned houses made out of railroad ties in "a small village of the Mexican plan. They have a common cook stove—a large stone oven that serves twenty families." When new railroad facilities expanded in the vicinity, however, the railroad relocated the families to a new area at about 900 South St. Francis Avenue. To serve these families, both Catholics and Protestants established churches. Our Lady of Guadalupe, above, served the Catholic faithful. The Mexican Protestant Church of Wichita, at right, worshipped in a stuccoed facility constructed with the help of donors such as A.A. Hyde, the founder of Mentholatum. (Right, courtesy Wichita–Sedgwick County Historical Museum.)

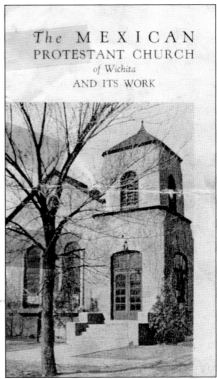

The MEXICAN
PROTESTANT CHURCH
of Wichita
AND ITS WORK

Mexican Soldiers on the Border

The economic crisis that prompted Mexican workers to migrate in the early 1900s led to a revolution that raged across Mexico during the 1910s. Rival warlords or *caudillos* such as Pancho Villa struggled for control of the country. Early in 1916, Villa attacked New Mexico, and later that year, the *Wichita Eagle* reported that Chief Hay dispatched "a squad of detectives and uniformed officers to search every Mexican shack and other abodes of the dusky residents in the city with orders to seize and store in city hall every weapon and all liquor found." A curfew ordered all Mexicans to remain off the streets after 9:00 p.m.

War Swept Mexico—Street Scene Showing Result of Fire of Heavy Guns

The 1915 Kansas census listed 135 Mexicans living in Wichita, most of them young men. When the United States joined World War I in 1917, some of those young men such as Julio Mendoza Sr. registered for the draft. Whoever filled out his registration card clearly had a problem spelling "Chihuahua." (Courtesy Anita Mendoza.)

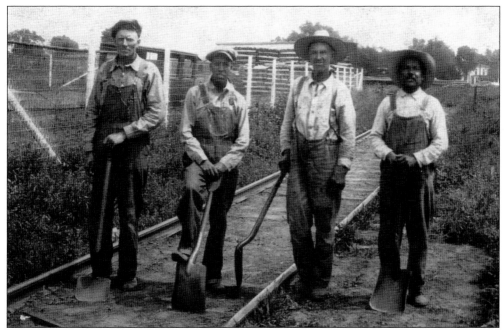

In the 1920s, the United States adopted a restrictive immigration policy based on a quota system to sharply curtail immigration from Europe but allow Mexican workers to continue to come in. Industry leaders made sure that their supply of relatively cheap and often seasonal Mexican laborers could continue. (Courtesy Carolyn Benitez and El Huarache Project Collection, Special Collections and University Archives, Wichita State University Libraries.)

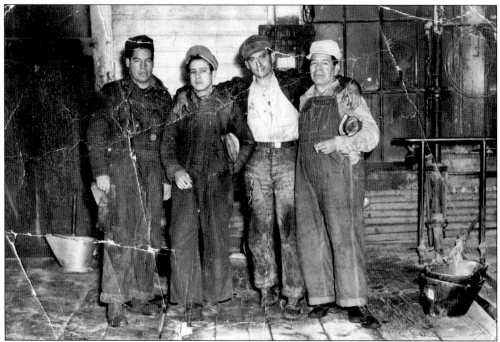

By the 1910s, barrios of workers extended across Kansas in places such as Newton, Wellington, Florence, and Wichita. In Newton (below), workers lived near the tracks in a community called El Ranchito that consisted initially of rough buildings constructed out of salvaged materials. In the 1920s, the railroad replaced these with brick buildings. Above, from left to right, Carlos Monarez, Adolph Del Castillo, Severo Chalio Curello, and Rosario Del Castillo are at work in Newton. All of them would eventually live in the North End. (Both, courtesy Vicki Monarez-Malter.)

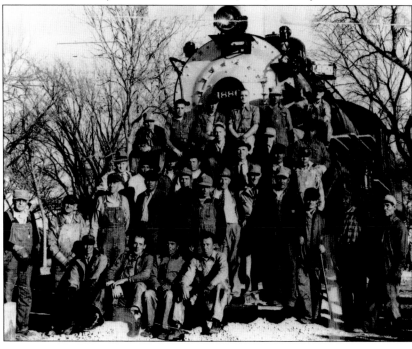

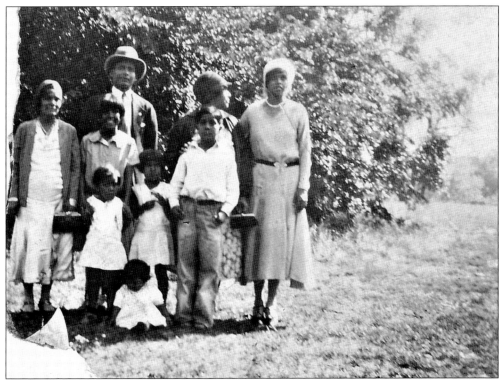

José "Joe" Rios and Adela Tellez Garcia met in Wichita and went to work in Omaha, then Texas, and then back to Wichita. From left to right are (first row) Lydia, Angie, and Elsie; (second row) unidentified, Esther, and David; (third row) Joe, Mary, and Adela. (Courtesy Michael Masias Rivers.)

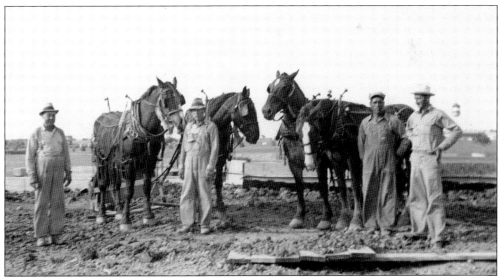

Some families worked with living animals as well as their carcasses. Santiago James Martinez, at left, is seen here with horses used for work around the stockyards. From Michoacan, Martinez originally came to work for the railroad. Like many North End Mexican workers, however, he switched to the packing plants early on. (Courtesy Angela Martinez.)

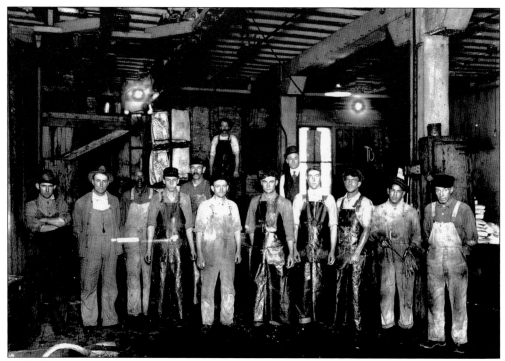

In the late 1910s, men like Antonio Macias found work in the packing plants, especially Cudahy. By the 1920s and 1930s, several Mexican American families worked at Cudahy, with family members able to get other family members and friends jobs at the plant. (Both, courtesy Wichita–Sedgwick County Historical Museum.)

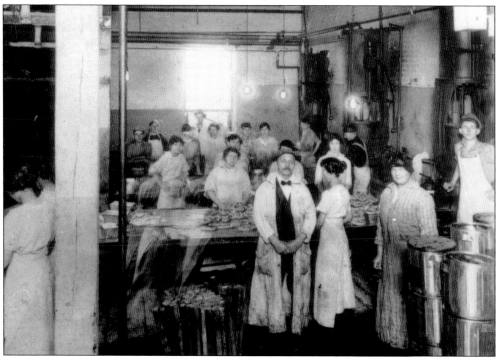

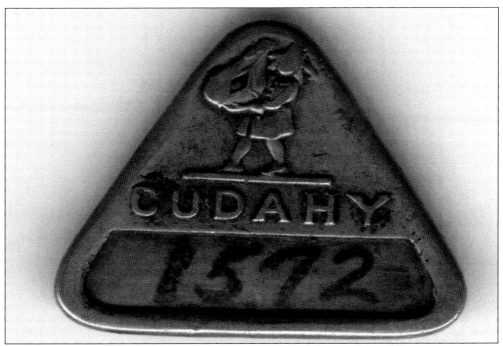

By the late 1920s, the Chicago-based Cudahy company had operations in a number of Midwestern cities, including Kansas City, Omaha, St. Louis, St. Joseph, Sioux City, and Wichita. The Wichita branch employed some 850 people to process cattle, hogs, and sheep. These identification badges show the transition from a metal pin to a paper card with a photograph. In 1968, General Host acquired Cudahy, which became Bar-S Foods in 1981. In 2010, Sigma Alimentos, a Mexican meat-packing company, acquired Bar-S. (Both, courtesy Carolyn Benitez and El Huarache Project Collection, Special Collections and University Archives, Wichita State University Libraries.)

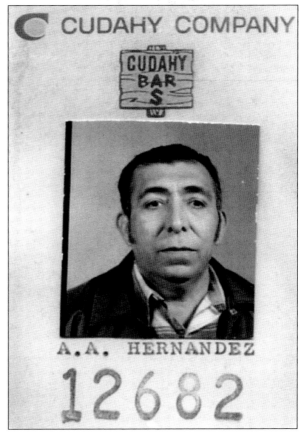

Most workers lived near the meat packing plants. The drawing above by Charles Capps entitled *Beside the Mill* shows how the community looked in 1934. As these images show, structures throughout the North End varied from modest wooden homes to shotgun houses to converted boxcars. Yards included space for gardens and some animals. (Above, courtesy Wichita Art Museum and the Wichita–Sedgwick County Historical Museum; below, courtesy Carolyn Benitez and El Huarache Project Collection, Special Collections and University Archives, Wichita State University Libraries.)

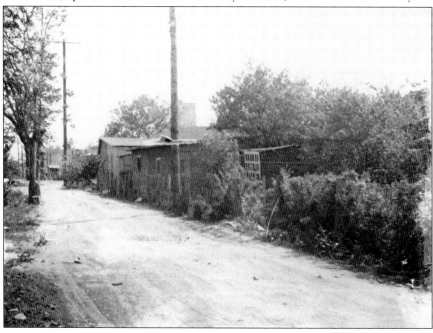

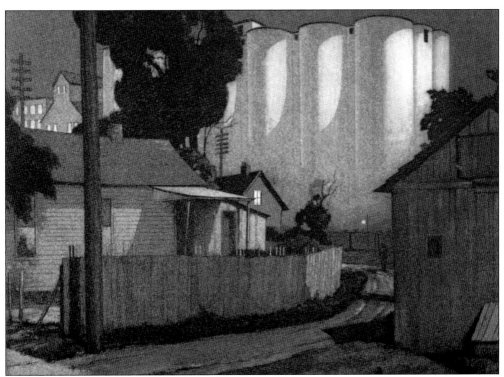

In 1937, a Home Owners Loan Corporation evaluation of the area described the housing as "poor" and "shacky." Still, as the image below of Luercia Chavez shows, there was a vibrance and life to the neighborhood. El Huarache was the main concentration of Mexican families in Wichita, but the North End was not majority Mexican at this time. The area's neighborhoods housed a mixture of immigrants from a variety of places including Mexico as well as working-class Anglo Americans. African Americans tended to live in adjacent neighborhoods initially to the south and later to the east. Dating from 1934, *Harvest Moon* by Charles Capps is seen above. (Above, courtesy Wichita Art Museum, Gift of Mosby Lincoln Foundation; below, courtesy Felecia Urbina.)

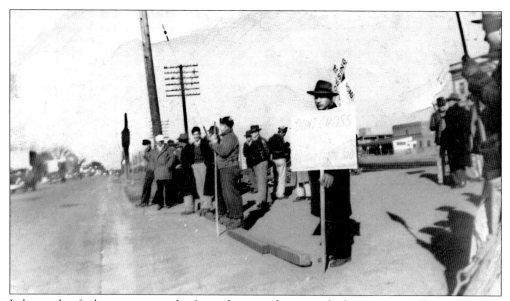

Labor strikes for better wages and safer working conditions took place occasionally. In this strike at Cudahy, a man holds a sign reading, "Don't Cross the Picket Line. It's Your Fight Too." Beside him at center left is Julio Mendoza. To the left of Mendoza is Pete Roman, and second from left in a white hat is Miguel G. Casanova. (Courtesy Anita Mendoza.)

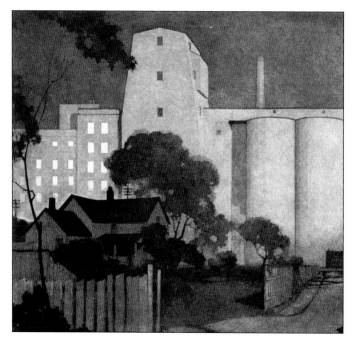

While most Mexican American families worked north of Twenty-First Street in the packinghouses, some worked in the mills and grain elevators, for the railroads, or in other nearby industries. Regardless of employment, they tended to live in communities along Twenty-First Street such as El Huarache or north of Twenty-First Street between Market and Jackson Streets. Charles Capps captured the imposing presence of the grain elevators and flour mills in the North End in his 1933 *Moonlit Mills.* (Courtesy Wichita Art Museum.)

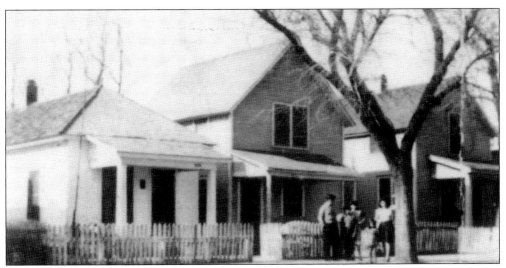

Ray Romero, National Football League Hall of Fame member, recalled, "Mom and Dad . . . bought a house in Wichita for $500 and made $5 a month house payments." The house is on the left in this 1945 photograph, with the Ornelas family at center and Gildardo Roman on the right. Like the Romans, many of the families in the neighborhood were also from Tepatitlán. While the Romeros and Ornelases worked at Cudahy, another neighbor, Joe Yñiquez, was a barber. (Courtesy Ray Romero and Benitez and El Huarache.)

Other neighborhoods included El Rock Isle, located along the Rock Island Railroad tracks in the vicinity of Twenty-Ninth and Ohio Streets. Families here had names such as Rodriquez, Alfaro, Diaz, Contreras, Cordoba, Ramirez, Canales, Espinosa, Gomez, Lopez, Mesa, Rios, Gonzales, Menendez, Martinez, and Aguilar. In this image, Concha Raigoza Aguilar appears at her home at 2802 North Wabash Avenue. (Courtesy Helen Navarrete.)

The first Catholic parish dedicated to Mexican families in Wichita was the Mexican Mission of Our Lady of Guadalupe established at Gilbert and St. Francis Streets and serving families who lived south of Douglas Avenue. Those who lived to the north were initially part of St. Patrick's Church. In the 1920s, a movement emerged to create a mission for Mexican Catholics separate from what was then a mostly Anglo parish. (Courtesy B.J. and Jonell Davies.)

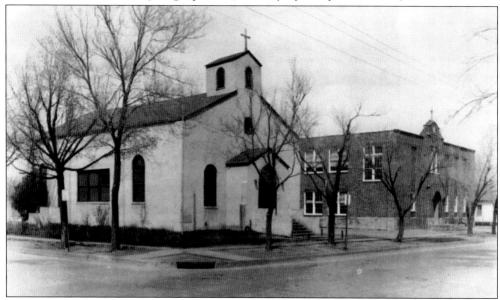

On July 23, 1927, groundbreaking took place for a north Wichita mission focused on Mexican families called Our Lady of Perpetual Help at Twenty-Fourth and Market Streets. In July 1932, the mission was granted to the Franciscan fathers of the Province of Cincinnati with Fr. Benedict Moellers as pastor. (Courtesy Carolyn Benitez and El Huarache Project Collection, Special Collections and University Archives, Wichita State University Libraries.)

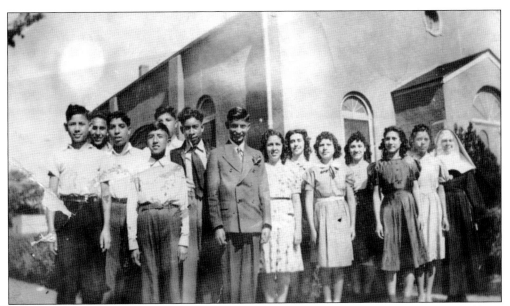

The North End's Catholic education system separated Mexican children from Anglo children. From 1923 to 1925, St. Patrick's set aside a room for Mexican children assigned to Sr. M. Anacleta. Our Lady of Perpetual Help dedicated its own school under the guidance of the German Sisters of the Sorrowful Mother, who were known for being strict—even mean. Children were expected to learn English, getting their hands rapped with rulers if they spoke Spanish. The image below shows a portion of the class in front of the school building constructed in 1935. (Above, courtesy Marcelino Chavez Jr.; below, courtesy Anita Mendoza.)

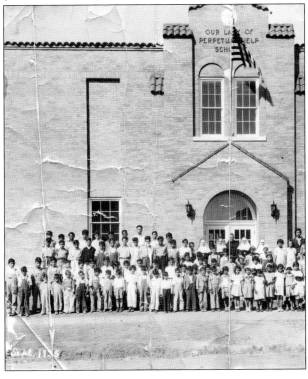

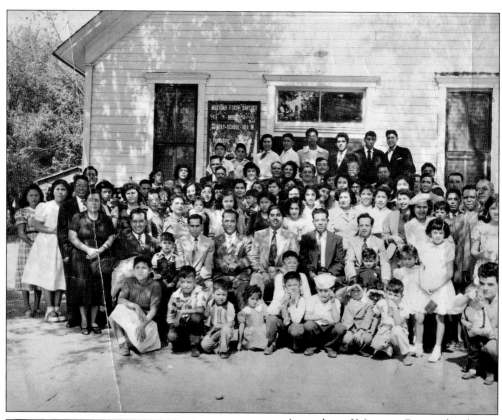

A number of Mexican Baptist families moved up to Wichita from Wellington and formed the core of the First Mexican Baptist Church. During their early years, their leader was Dr. Hector Franco, who noted that in Mexican churches, "the pastor is not just the preacher, he is an interpreter, teacher, lawyer, youth director, a member of the selective service board, a banker, a technical advisor, etc." (Courtesy Michael Masias Rivers.)

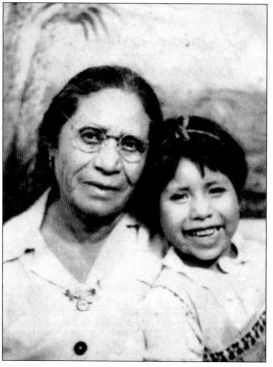

Felicitas Cruz, on the left, became a landlady in the North End, owning properties along Twenty-First Street. A member of the Mexican Baptist Church, she donated one house to serve as the minister's home. (Courtesy Don Cruz.)

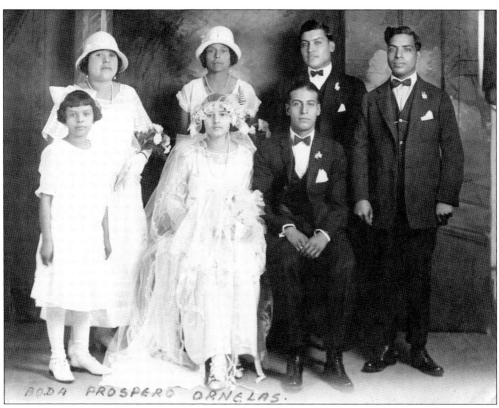

Photographs such as this one were sent to relatives in Mexico to show how far the family had come. In this image, Prospero Ornelas appears with his bride, Maria Roman. Standing behind Prospero is his brother Donato. Behind the bride is Maria Martinez, Donato's wife. José Camacho is to the right of Donato while his wife, Lupe Larez, is on the far left. The young girl is unidentified. (Courtesy Vicki Guzman Cruz.)

Mexican customs persisted in the North End, such as the dances of the Matachines in December. In these events, dancers in colorful costumes and masks, which combine Spanish, Mexican, and pre-Columbian symbols, replay the interactions between Christians and non-Christians. (Courtesy Carolyn Benitez and El Huarache Project Collection, Special Collections and University Archives, Wichita State University Libraries.)

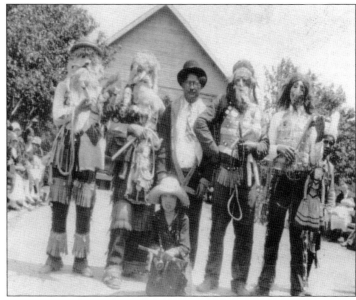

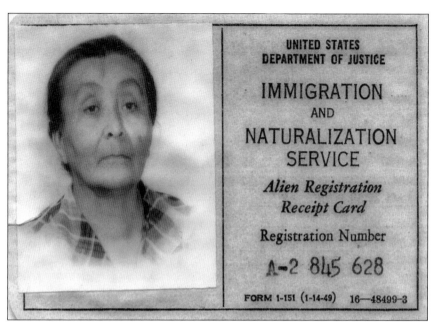

With the onset of the Great Depression, a number of Anglo American people, including some in the labor movement, thought of Mexican workers as foreign competition to native-born laborers. Across the country, an estimated half million Mexican nationals and Mexican Americans were deported to Mexico. In Kansas, railroads and other industries objected, arguing that Mexicans were too few in number to have made much of a difference in employment. Cudahy, too, retained its Mexican workers and so the North End did not experience the deportations that took place elsewhere. Even so, US immigration policy now required visas to stay in the country. Work visas and alien registration documents became necessary, such as this one for Maria Ortega de Hernandez. (Both, courtesy Carolyn Benitez and El Huarache Project Collection, Special Collections and University Archives, Wichita State University Libraries.)

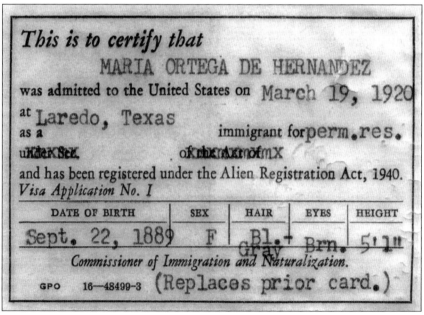

These papers of the Roman family show the story of one family's journey. José Jesus Roman initially arrived in the United States to work as a master mechanic for the Missouri Pacific Railroad in New Mexico. He brought his wife, Dolores Rios, to Albuquerque; the photograph on the paperwork at right shows her with her children Gonzalo, Antonio, Andrea, and Maria. A fifth child, Elena, was born later in the United States. The Missouri Pacific transferred José and the family to Wichita, where they lived at 2338 North Jackson Street. He remained proud of his Mexican background and made sure his grandchildren learned Spanish, teaching them by going over articles in the newspaper *La Prensa*. Already a Roman, Andrea went on to marry another Roman, José Angel, whose naturalization paper appears below. (Both, courtesy Amelia "Tillie" Roman Ornelas.)

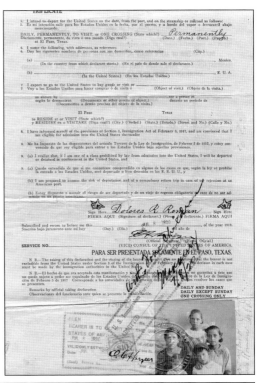

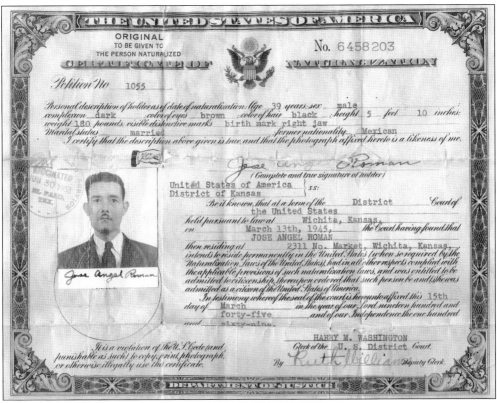

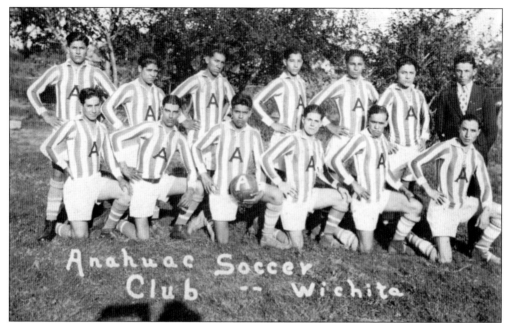

Sports became an important part of life. The Anáhuac soccer team of 1927 featured many of the families of the Mexican American North End. From left to right are (first row) Panfilo Vargas, Benigno "Harry" Lopez, José Q. Tejeda, José Garcia, Eliseo Hernandez, and Juan Castro; (second row) Cuco Gascon, Julian Murguia, Mike Casanova, Gildardo "Gil" Roman, Nieves "Tex" Diaz, Juan Macias, and José Rosales. (Courtesy Raymond Olais and Marie Garcia.)

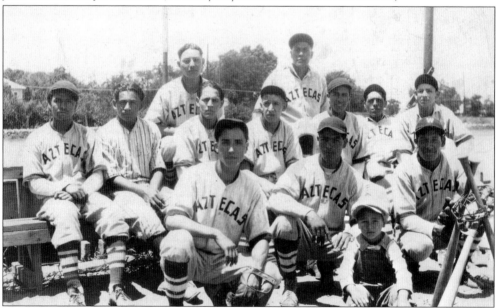

In 1928, Arnulfo Valdez and Santiago "Jimmy" Martinez formed the first Mexican American baseball team, the Aztecas. From left to right are (first row) Juan Castro and Louie Azteca; (second row) Juan Sanchez, Albert Granados, Joe Minjarez, and Louie "Manuel" Murgia; (third row) Pete Roman and Laloa Torres. The little boy and man on the right are unidentified. (Courtesy Marie Garcia, Amelia "Tillie" Roman Ornelas, and Caroline Ornelas Kelley.)

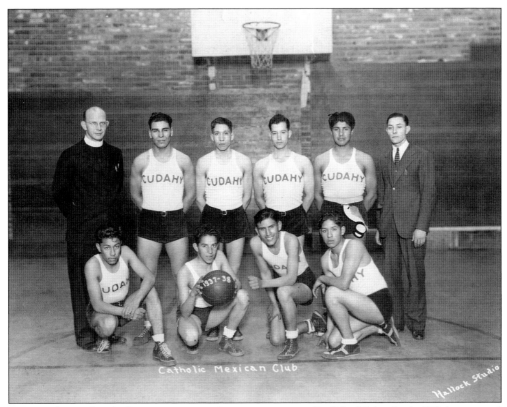

Turning down a baseball contract prior to becoming a priest, Fr. Giles Hukenbeck, OFM, remained an avid golfer and basketball coach. Father Giles stands on the far left. From left to right are (first row) Mario Renteria, Ned Labrado, Paul Flores, and Alvaro "Whitey" Rosales; (second row) Hukenbeck, "Tex" Diaz, E.Z. Santiago, Gildardo "Lalo" Roman, Izzy Sanchez, and Pete Roman. (Courtesy Anita Mendoza.)

Although not Mexican himself, Father Hukenbeck was a respected member of the community and was able to converse in both English and Spanish. Here he stands on the right of this first communion group. Father Giles served the parish for 25 years. (Courtesy Anita Mendoza.)

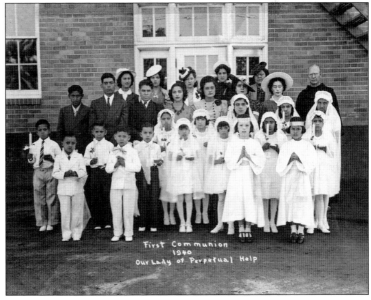

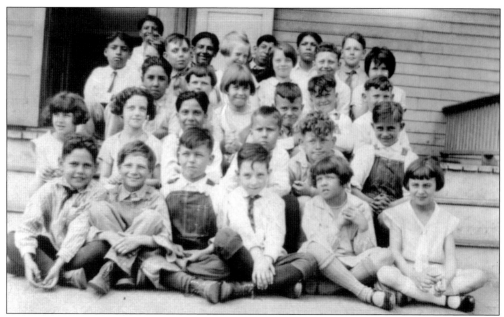

Wichita's school leaders segregated whites and blacks into separate elementary schools and launched an unsuccessful attempt in 1921 to create a separate school for Mexican children. Most children of Mexican American descent who did not attend Catholic school went to Irving, as in the above image from 1927, or Waco Elementary. Those who went on to middle school often attended Horace Mann, as seen below in a class photo in front of St. Paul's Methodist Church. Several of those who were fully bilingual recalled how speaking Spanish was seen as a learning disability. (Both, courtesy Anita Mendoza.)

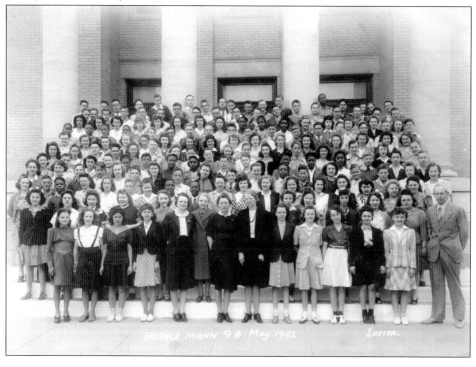

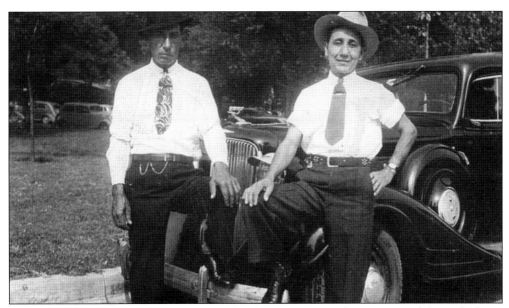

Automobiles shaped the lives of families like the Casanovas. Jake Casanova, left, worked as a trash hauler. On the right is Manuel Casanova, whose brother Miguel worked in Michigan in the car industry before coming to Wichita to work for Cudahy. (Courtesy Linda and Lydia Santiago.)

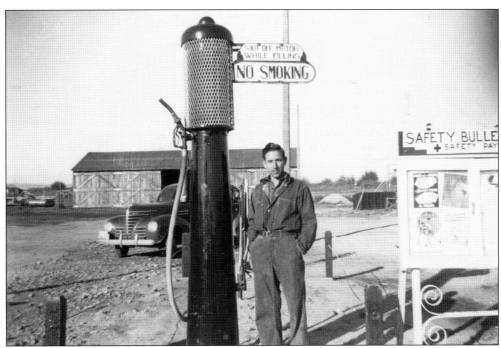

Julius Mendoza is seen here working at a gas station on North Broadway. He went on to drive trucks for the House of Schwan but is perhaps best known for being a golfer, having played with Los Patos for many years. (Courtesy Anita Mendoza.)

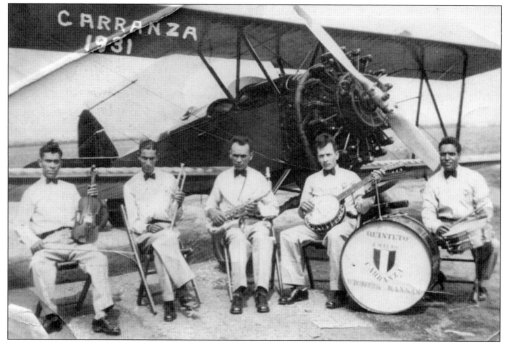

Dances were important parts of North End life, held in homes, parish halls, hotels, and outdoor areas like Heller's Grove. Cudahy held dances at the company athletic hall, albeit segregated. In December 1921, for example, Cudahy held three dances on separate nights: one for whites, another for "colored folks," and a third for Mexicans. Across the North End, musicians became local celebrities. This band shows its Wichita spirit by posing in front of an airplane. (Courtesy Carolyn Benitez and El Huarache Project Collection, Special Collections and University Archives, Wichita State University Libraries.)

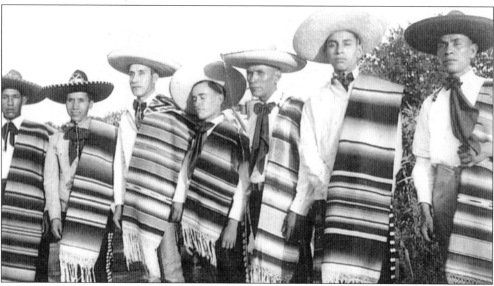

From left to right are Alvaro "Whitey" Rosales, Mercedes "Shorty" Santiago, either Juan Triana or Lupe Zamorano, Pete Zamorano, unidentified, Paul Triana, and Victor Triana. (Courtesy Rosalie Rosales de Lopez.)

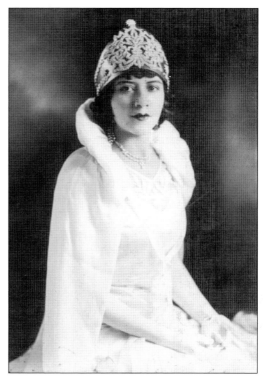

Celebrating Mexican independence on September 16, families in the North End kept traditions such as reciting the 1810 speech known as "El Grito de Dolores." Starting in the 1920s, members of the Wichita Mexican community held a festival that included crowning a Mexican Independence queen. These images from 1928 show Maria Roman as queen. She was also crowned queen of a summer fiesta. Below, Alberto "Bert" and Isabel Macias pose in Mexican attire that reflects what these celebrations might have looked like. (Right, courtesy of Amelia "Tillie" Roman Ornelas; below, courtesy of Michael Masias Rivers.)

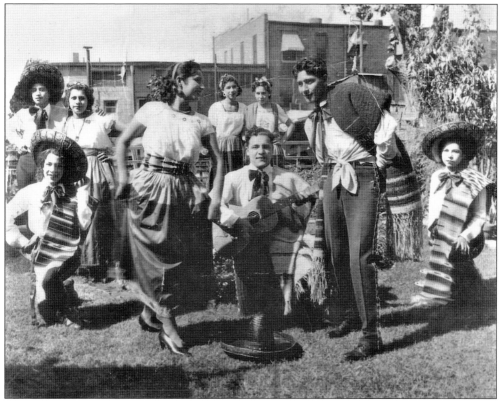

As workers settled down and had children, networks of siblings and cousins tied the North End families together. For example, the Martinez family were among the railroad workers who came to Kansas. They lived initially in Florence, Kansas, before coming to Wichita where they first lived in a boxcar house along the tracks. By the 1940s, they lived in a modest wooden house at Twenty-Second Street and Broadway. In the 1945 image below, Virginia Martinez-Mendoza stands in front of this house. (Both, courtesy Anita Mendoza.)

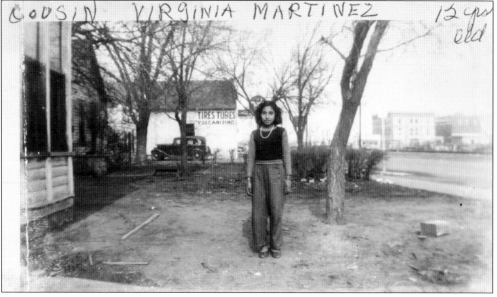

COUSIN VIRGINIA MARTINEZ 12 yrs old

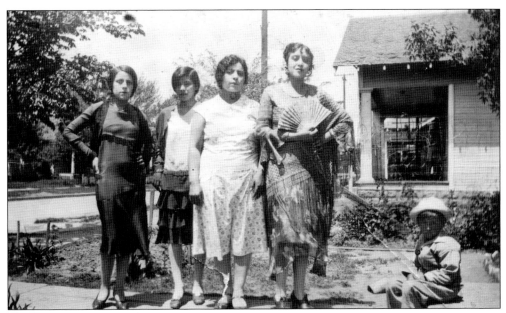

The first immigrants to the North End often did not get photographed. Their younger siblings, children, nieces, and nephews, however, seemed to delight in creating those early-20th-century versions of the "selfie" that showed their air of confidence and fashionable clothes. Among them are, seen above, the women of the Ornelas family or, at right, Lupe Gascon and Lucy Gallardo. (Above, courtesy Vicki Guzman Cruz; right, courtesy Carolyn Benitez and El Huarache Project Collection, Special Collections and University Archives, Wichita State University Libraries.)

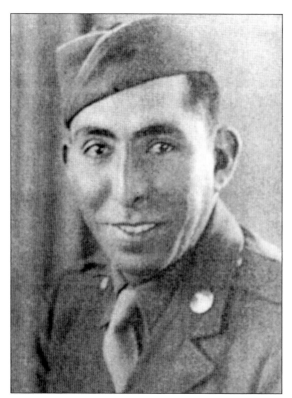

Serving in the military became a rite of passage for many young men in the North End. Over 350,000 Mexican Americans served the United States during World War II. Many who served were born in Mexico, as was the case for Alfonso Hernandez, who was born in San Luis Potosí. (Courtesy Rosalie Rosales de Lopez.)

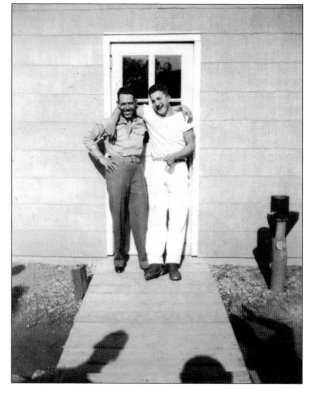

Born in Ocampo, Nuevo Leon, Mexico, Rafael Lopez enlisted in the army from San Antonio, Texas, and served in Germany. He is pictured here as a private at Fort McClellan, Alabama. Later on, a career tied to the Air Force brought him to Wichita. (Courtesy Carmen Rosales.)

Julian Murgia poses at Santa Maria, Italy, where he served as a paratrooper. It is estimated that half a million Hispanics, who included Mexicans, Puerto Ricans, and those from the Hispanic families of the Southwest, participated in World War II as part of the US Army. (Courtesy Anita Mendoza.)

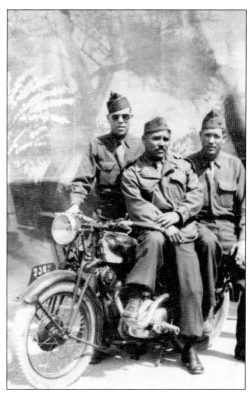

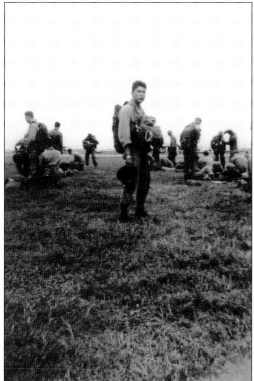

Serving in the Pacific, including the liberation of the Philippines, Donato Ornelas was a paratrooper, having made some 18 jumps. When he concluded his service, he had received a Bronze Star as well as a World War II Victory Medal and the Philippine Liberation Ribbon. (Courtesy Brenda Ornelas McKellips.)

Wartime labor shortages allowed women to join the war industry, among them Connie Cuellar. When her fellow riveters at Boeing refused to work with a black colleague, she stepped forward and the two built nose cones for B-29 bombers. Now Connie Palacioz, she volunteers on the restoration of the bomber called *Doc* that she helped build in the 1940s. (Courtesy Connie Palacioz.)

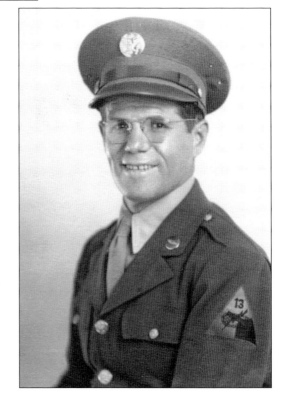

Born in Jalisco, Mexico, Joe Garcia was the son of an immigrant to Mexico—from Spain. In 1941, he became a naturalized citizen, and in this image, he is seen in uniform as part of Company C of the 46th Armored Regiment. While some families left Mexico never to return, Garcia and his family visited regularly. (Courtesy Marie Garcia.)

After World War II, Mexican American GIs found that even serving their country did not always result in fair treatment, with US-born soldiers in uniform being denied jobs and services because they were still assumed to be foreigners. In 1948, Dr. Hector P. Garcia, a surgeon and World War II veteran, formed the GI Forum, an organization that helped address the concerns of Mexican American veterans. In Wichita, Martin Ortiz, seen at right, came back from the war to find himself not welcome in Anglo VFW activities and, as a result, became one of the founders of the local GI Forum. Given the age spread of the Ortiz children, Martin's youngest siblings served in Vietnam. (Right, courtesy Tirso Ortiz; below, courtesy Victoria Estrada.)

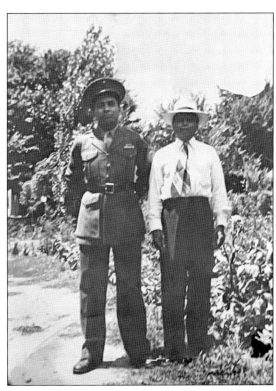

AMERICAN
GI FORUM
OF KANSAS

June 14-15-16, 1968

BAKER HOTEL

HUTCHINSON, KANSAS

FOURTEENTH ANNUAL STATE CONVENTION

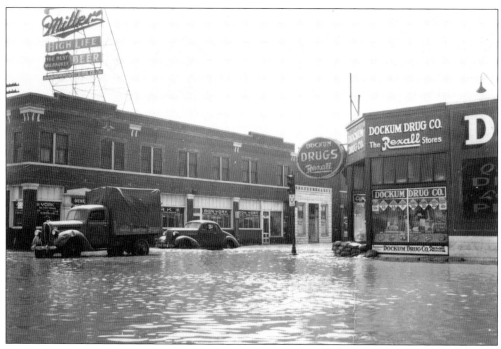

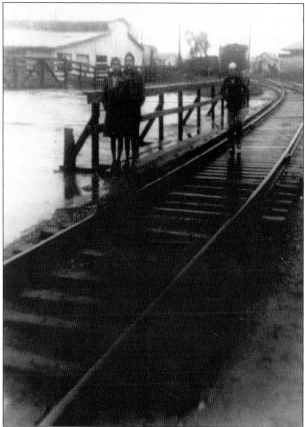

Before the construction of the "Big Ditch" in the 1950s, the Arkansas River remained prone to flooding, and the flood of 1944 was especially bad. Looking southeast at Twenty-First Street and Broadway Avenue, the floodwaters reached the Flatiron Building. Mike Rosales Jr. remembered that flooded streets "were the only time we had a swimming pool." (Above, courtesy Juanita Lepe; left, courtesy Carolyn Benitez and El Huarache Project Collection, Special Collections and University Archives, Wichita State University Libraries.)

It was at dances in Wichita that three Hernandez sisters from Blackwell, Oklahoma—Connie, Emily, and Jenny— met with three Rosales brothers. Here, Alvaro "Whitey" Rosales is with Maria "Jenny" Hernandez. Connie married Mike Rosales, and Emily married Lupe Rosales. Eventually, the three pairs lived next to each other at 2321, 2325, and 2327 North Market Street. (Courtesy Ron Rosales and Rosalie Rosales de Lopez.)

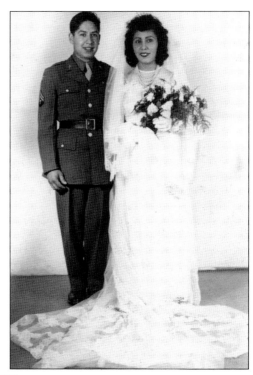

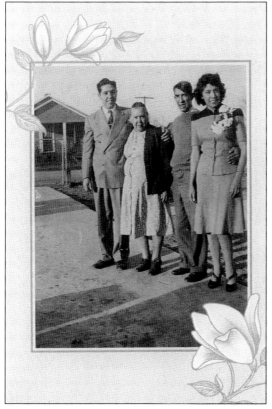

Originally from Leon, Guanajuato, Mexico, Evaristo Rosales was in the shoe repair business in Wichita. The Rosales family lived at 1918 North Mosley Street and the Hernandezes lived at 807 East Nineteenth Street. Here, Miguel "Mike" Rosales is to the left with his parents, Juanita and Evaristo, and his bride, Concepcion Hernandez, on their wedding day in 1946. (Courtesy Ron Rosales.)

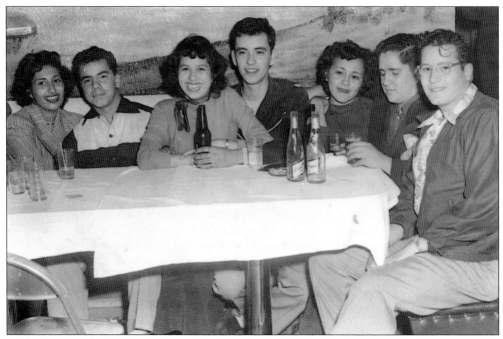

In the 1940s and 1950s, going out to clubs was a regular part of life in Wichita, and North End families were no exception. Here at the Blue Moon are, from left to right, Virginia and Anthony Mendoza, unidentified, Oscar Castro, unidentified, Gilbert Gutierrez, and Robert Ornelas. (Courtesy Anita Mendoza.)

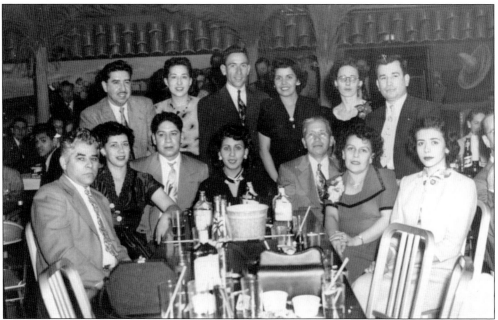

Seen here at the Blue Moon in the 1950s are, from left to right (first row) Julian and Angelina Murguia, Alvaro "Whitey" and Juanita "Jenny" Rosales, Mercedes and Mary Santiago, and Martha Vasquez; (second row) Lupe Rosales, Emily Rosales, Julius and Delphine Mendoza, and Maxine and Pete Zamorano. (Courtesy Rosalie Rosales de Lopez.)

When the family of Felicitas Cruz visited relatives in San Pedro, Piedra Gorda in Zacatecas, Mexico, it took a while for them to even locate their relatives. It was only when grandson Don happened to notice a woman they drove past as having a family resemblance that they stopped the car and found Felicitas's sister. Here, Angel Cruz and Concha Casanova stand next to her. (Courtesy Don Cruz.)

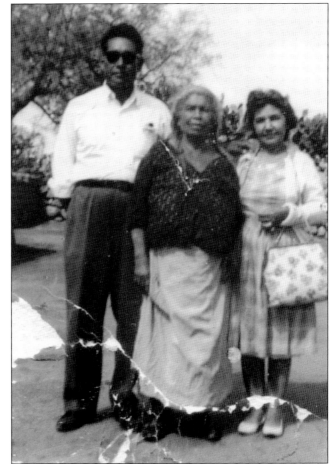

For some families, life in the United States was a new start and they never looked back. Other families, however, maintained contact with relatives in Mexico and even went down to visit. Here, Maria and Julio Mendoza are at the top far left with a group of relatives in Mexico City. (Courtesy Anita Mendoza.)

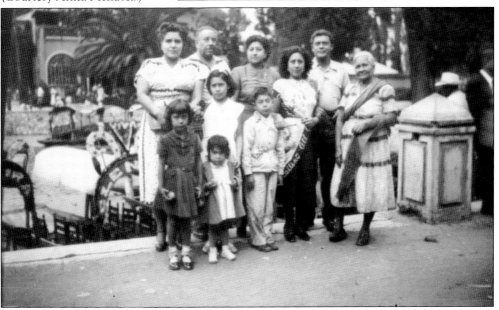

59

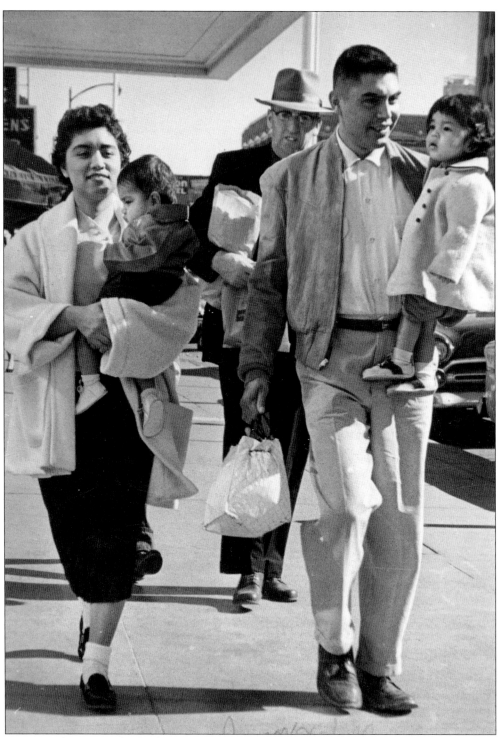

Donato and Lupe Ornelas do their shopping with Brenda and Donnie on Twenty-First Street. The family recalled that "we did most of our shopping on Twenty-First and Market Street." (Courtesy Brenda Ornelas McKellips.)

Three

"UPTOWN"

In the middle decades of the 20th century, life in the north part of Wichita bustled with activity. Work at the packinghouses, the refinery, and the mills allowed nearby residents to afford a modest but comfortable standard of living. Businesses along Twenty-First Street and Broadway served the needs of families whose small frame houses extended out in all directions. For families of color, there were opportunities for a better life than their parents had known. As Hector Franco put it in 1950 in his dissertation "The Mexican People in the State of Kansas," "To-day they are just beginning to feel that they belong to this country. To-day they are beginning to acquire new skills, more education, better jobs, and in the near future, as useful citizens and proud Americans, they will enlarge their fields of endeavor and will make other contributions to the United States."

Even so, restrictions and limits on those promises were never far away. Young men and women wrestled with how to respond, some feeling it was best to blend into US society while others proudly celebrated their distinctive Latin American identity. Some served in the military, following a sort of family tradition: the grandfather may be a World War II veteran or—as fictionalized in Chicano playwright Luis Valdéz's *Soldado Razo*—the father may be drafted to Korea and the son go to Vietnam.

The next generations found incentive (or pressure) to stay with the stable, reliable work of the plants, but there were other opportunities. Some worked for the aircraft industry. Others went into business in construction or the trades. Several families founded restaurants, and names like El Patio, Chata's, Felipe's, and Connie's became beloved establishments. Some, such as Mike Rosales Jr. and Carolyn Rosales Benitez, served their community through nonprofit work. A cohort went on to study at universities where several became active in civil rights groups. Some favored assimilation into Anglo-American Wichita society and joined established groups and organizations. Others rejected assimilation and joined the ranks of the Chicano movement, leading to schisms between generations and within families over claiming Mexican American, Hispanic, Chicano, or simply "American" identities.

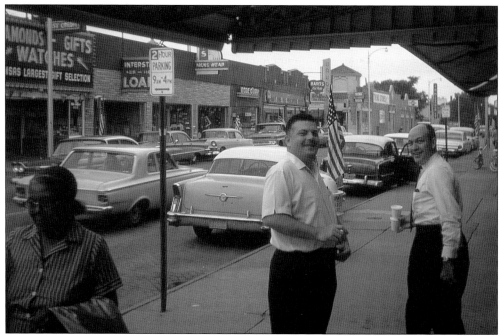

During the 1940s, 1950s, and 1960s, the North End hummed with businesses that served families who worked along Twenty-First Street and the North End industrial corridor. Given that Broadway was US Highway 81, there were also tire shops, filling stations, motels, and garages. While Mexican Americans were part of the mix, the neighborhood was still majority white at this time. The Dockum Drug Store stood at the southwest corner of Broadway and Twenty-First Street. Other businesses included diners, drugstores, jewelers, and appliance shops. Mexican American families recalled that some businesses welcomed their patronage. Others did not. (Both, courtesy Mike Maxton.)

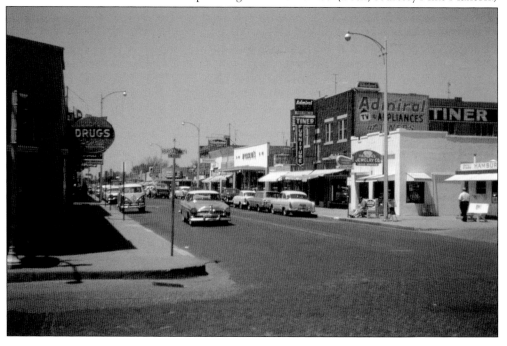

Marie Garcia, on the left, appears with a Roman neighbor in the family backyard at 2320 North Market Street. In back, across Broadway, are the buildings of Cudahy. (Courtesy Marie Garcia.)

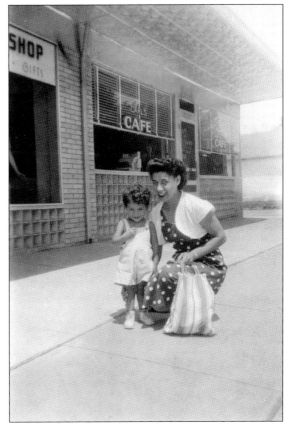

Doing their Saturday shopping in the North End, Angelina Mendoza-Murgia and Bobby Murguia are at Twenty-First Street and Waco Avenue in 1951. (Courtesy Bobby Murguia.)

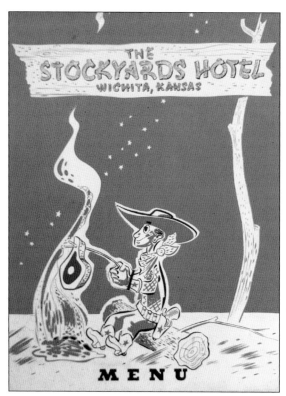

Development along Twenty-First Street, which Spanish-speaking locals sometimes called "La Veintiuna," included hotels for those conducting business with the meatpacking industry. On the south side of Twenty-First Street next to the exchange, the Stockyards Hotel restaurant had a reputation for its steaks. This was just one of several steakhouses in the northern part of Wichita. Below, Mary Soliz Diaz appears with the Livestock Exchange headquarters in the background from the Skelly filling station. (Below, courtesy Carolyn Benitez and El Huarache Project Collection, Special Collections and University Archives, Wichita State University Libraries.)

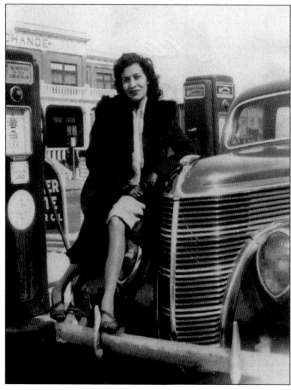

Located at Twenty-Fifth Street and Arkansas Avenue, Ray Sailor's sporting goods store was a local hangout. In the 1950s, brothers J.W. and B E. "Beatle" Baum bought the store and ran it until it burned in 1968. In this image, Beatle Baum is filling up a car's gas tank. (Courtesy Janiece Baum Dixon and the Wichita–Sedgwick County Historical Museum.)

Following World War II, Wichita and the North End entered into a new period of prosperity that allowed at least some families to afford automobiles. In time, the dominance of the automobile also contributed to the decline of the North End. No longer did families have to live within walking distance of the plants. They could commute to work. (Courtesy Carolyn Benitez and El Huarache Project Collection, Special Collections and University Archives, Wichita State University Libraries.)

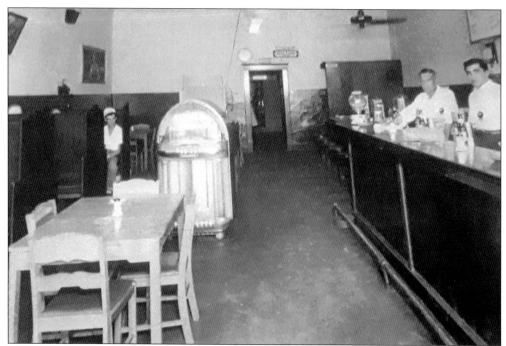

In the 1940s, the Zimmerman family owned the buildings at 2225 and 2227 North Broadway Avenue. Sacramento Ledesma operated the upstairs, 2227 ½, as a boarding house called the North Wichita Hotel. Meanwhile, Anthony Oropesa ran a pool hall downstairs and later brought in his brother in law Nick Hernandez as a partner. By the 1950s, the first floor had become El Patio Cafe. El Patio became known for "Nick's Special," a flat tortilla covered with chile verde and, on weekends, menudo. (Both, courtesy Rosalie Rosales de Lopez.)

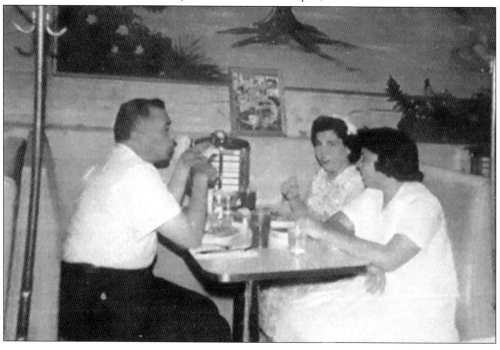

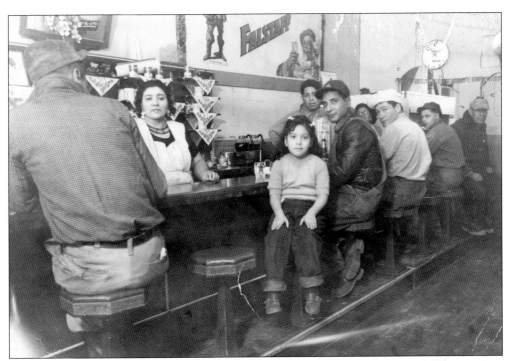

Chata's stood at 1225 North Broadway Avenue, taking the name of Aurelia "Chata" Ornelas. Above, Chata is behind the counter, with her daughter Vicki seated at center. Vicki's father, Victoriano Guzman, is peering over the shoulder of a seated Joe Hernandez. This was during the lunch rush at the packing plants, when workers of different backgrounds ate together. At right, a jukebox provided music. Vicki recalled that the family home was small so Chata's was the place for family celebrations and community gatherings. (Above, courtesy Vicki Guzman Cruz; right, courtesy Carolyn Benitez and El Huarache Project Collection, Special Collections and University Archives, Wichita State University Libraries.)

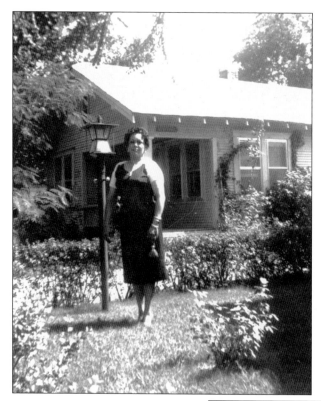

Delfina "Delphine" Garcia, standing here in her front yard at 2320 North Market Street (with the home of Gil Roman in the background), was known for her cooking. For years, she was known as the go-to person for tortillas in the community. Daughter Marie remembers delivering parcels of food on her bicycle to stores along Twenty-First Street. (Courtesy Marie Garcia.)

Rafael Lopez came to Wichita after the Korean conflict and was a barber at McConnell Air Force Base. His wife, Concepcion, or "Connie," became famous for her cooking at St. Margaret Mary, one of the south Wichita parishes. In 1963, she moved into the site of Chata's and opened one of the city's best-known restaurants. When El Patio moved in the 1970s, the Lopezes acquired the entire building. (Courtesy Carmen Rosales.)

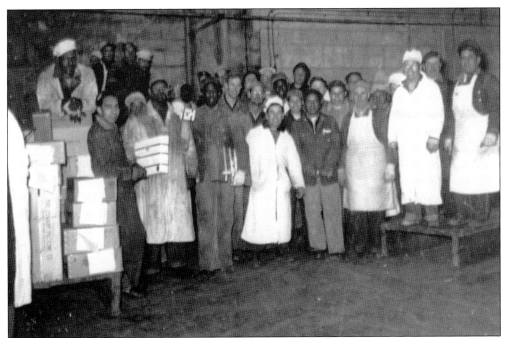

The packing houses provided stable work and many families had multiple members and multiple generations working in the plants. The men above include Joe Iñíguez, Joe Roman, Pete Zamorano, Manuel Diaz, Whitey Lopez, Julian Murgia, "Shorty" Zamorano, and A.Z. Lopez. Below, from left to right, are Floyd Stark, Nieves "Tex" Diaz, Pete Roman, and Alfonso Hernandez. Women also worked in the plants, especially in areas that processed hot dogs or sliced bacon. Young people wanting to go to college could work in the plants during the summer to earn tuition. (Above, courtesy Rosalie Rosales de Lopez; below, courtesy Carolyn Benitez and El Huarache Project Collection, Special Collections and University Archives, Wichita State University Libraries.)

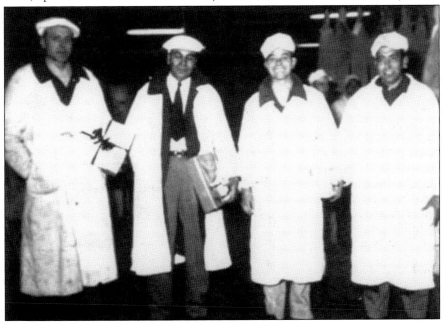

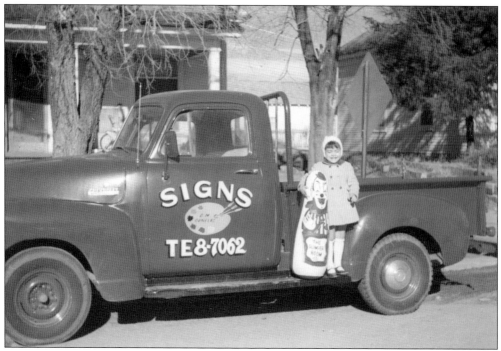

After World War II, Donato Ornelas became a sign painter. In this image is his daughter Melissa, who stands on the running board of her father's truck. (Courtesy Brenda Ornelas McKellips.)

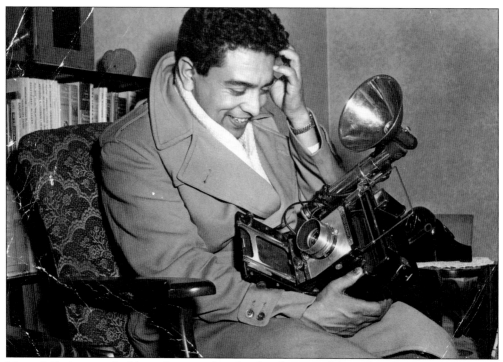

Manuel Ortiz was a budding photographer, but local papers did not hire him because he was Mexican. He was killed in a car accident shortly after this shot was taken. (Courtesy Tirso Ortiz.)

The neighboring African American community ranged from the business hub of Ninth Street and Cleveland to farm families just north of the packing plants. Some families also lived alongside Mexican Americans, such as the McConicos who lived on North Wabash Avenue in El Huarache. The man with the hat on the left is Pete McConico. (Courtesy Mark McCormick.)

After the war, several members of the younger generation got jobs elsewhere in the city. Here, Julian Murguia works for Coleman. Others worked for the aircraft plants. Taking jobs in other parts of the city motivated a number of families to start moving out of the North End altogether. (Courtesy Bobby Murguia.)

71

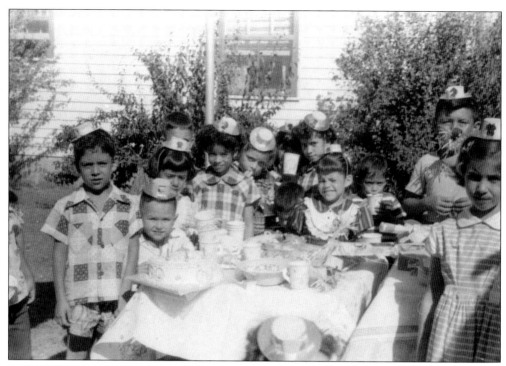

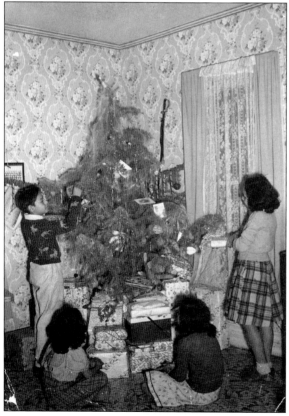

As with the rest of Wichita, Mexican American families embraced postwar traditions such as children's birthday parties and elaborate Christmas events. In the above image, Bobby Murgia celebrates his birthday. At left, from left to right, Tirso, Margaret, Betty, and Gloria Ortiz celebrate Christmas in their home at 2228 North Park Place. (Above, courtesy Anita Mendoza; left, courtesy Tirso Ortiz.)

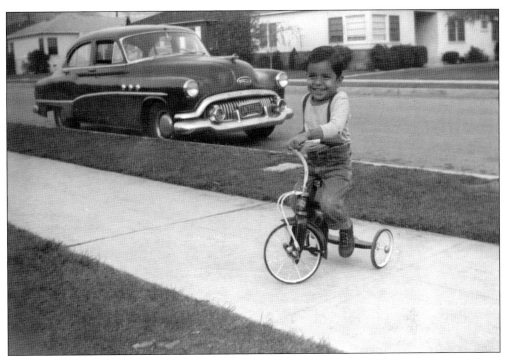

By the 1950s, suburban development pushed west of the Little Arkansas River to include subdivisions such as Indian Hills and Twin Lakes. For the next generation of Mexican Americans, success meant moving out of the North End to the suburbs with good jobs and the GI Bill helping finance a home in a new development. Here, a young and ornery Tirso Ortiz grins on his tricycle on just such a suburban street. (Courtesy Tirso Ortiz.)

For many families, moving out of the old frame houses into newer homes or even to the suburbs was a sign of prosperity. Here, Virginia Martinez-Mendoza takes a moment to pose for a picture while walking in the North End to visit friends, something she and her friends enjoyed doing. (Courtesy Anita Mendoza.)

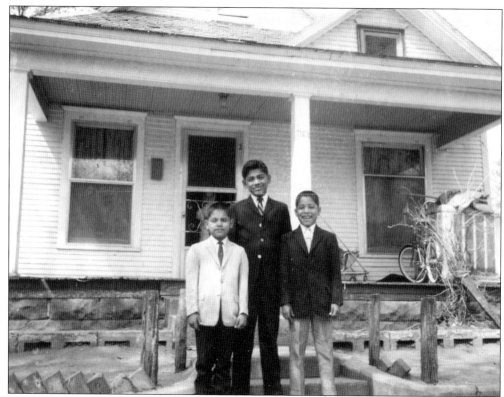

By the 1950s, most families lived on streets like Market Street, Park Place, and Wellington Place. These were near Our Lady of Perpetual Help, which was a major community gathering place as well as a place of worship. Here, Donnie, Ronnie, and Marty Ornelas are dressed for Easter services in front of their house on Twenty-Second Street. (Courtesy Brenda Ornelas McKellips.)

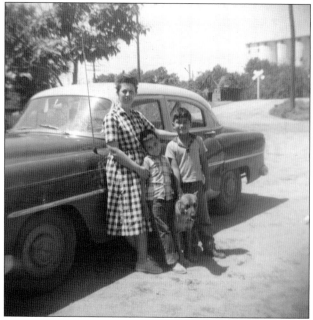

El Huarache was already fading by the time Anna Ornelas posed here with Rene, Gil, and Butch the dog. By this time, the first residents had aged and moved to new housing. By the 1960s, urban renewal had cleared the remaining buildings. (Courtesy Vicki Guzman Cruz.)

Cuban-born Joseph Angulo was a leader of the Mexican Protestant Church and a professor of Spanish at Wichita State University for 37 years. He was also one of the founders of the Pan-American Club that, as Mexican-born Hector Franco, put it, "is a cultural group. It meets with the sole idea of enjoying the Spanish language, Spanish music, Spanish environment, real Pan Americanism." (Courtesy Susan Angulo Stallings.)

As World War II came to a close, society saw a wave of weddings take place. In 1951, Francisco "Pancho" Ornelas married Raymunda Garcia. In this image, the wedding party celebrates at the Mambo Club on North Hillside Street. (Courtesy Vicki Guzman Cruz.)

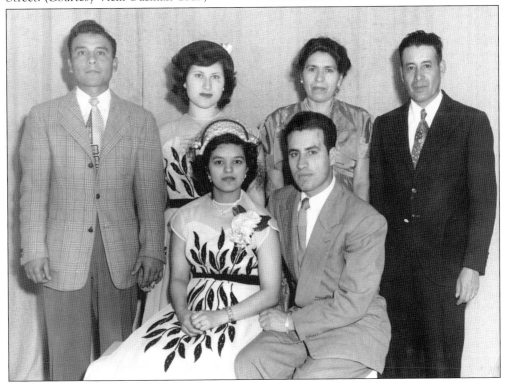

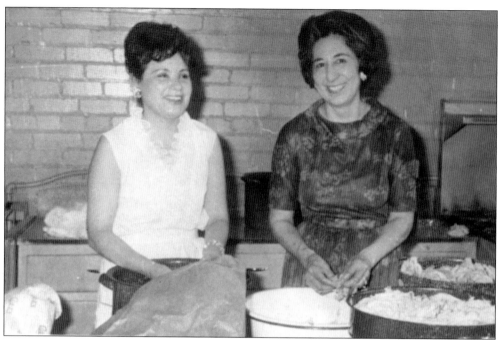

The women of the North End have been preparing food for church sales since the establishment of the church. Bea Espinosa and Emily Rosales are seen here preparing food at Our Lady of Perpetual Help. Food sales during Lent have been a tradition for years (with the exception of COVID-19 in 2020) and have included enchiladas, tacos, beans, and rice. (Courtesy Rosalie Rosales de Lopez.)

Michael Masias Rivers said, "My grandmother Maria Adela Tellez Garcia was always in her kitchen cooking . . . there was always food ready for . . . anyone." (Courtesy Michael Masias Rivers.)

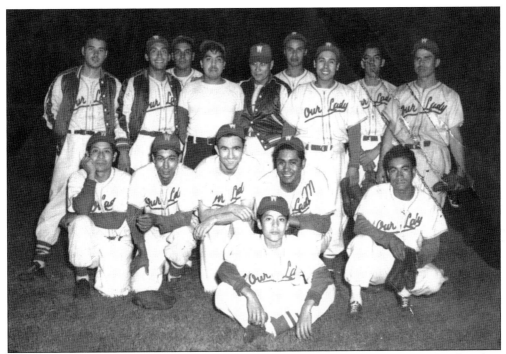

Baseball had tied together Mexican Americans across Kansas since the days when railroad workers took up the sport. In the 1930s, they encountered a world literally segregated between black and white and had to form their own leagues, like the Mexican American league of Newton, to play. This shot of the Our Lady of Perpetual Help team from the 1950s shows the sport in its heyday. (Courtesy Natalie Castro Olmsted.)

Boxing had become an important part of Mexican American life as well. Marshall Villa Jr., seen here on the left with his brothers Vincent (center) and Pat, became the head of the Villa Boxing Club. (Courtesy of Israel Villa.)

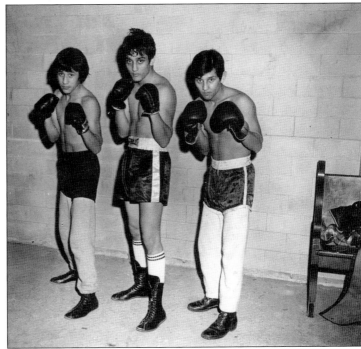

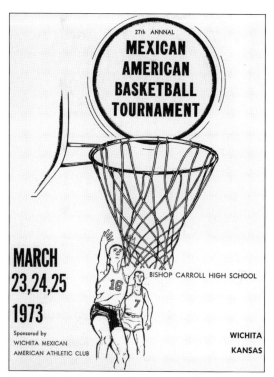

In the 1940s, the Mexican American Basketball Tournament became a local tradition. The championship event ended with a dance in which a young woman was crowned tournament queen. Below, Wichita State University basketball coach Gary Thompson crowns Carmen Lopez queen of the Mexican American Basketball Tournament next to her date, Jim Garcia, in 1965 at the Broadview Hotel. (Left, courtesy Marcelino Chavez Jr.; below, courtesy Wichita–Sedgwick County Historical Museum.)

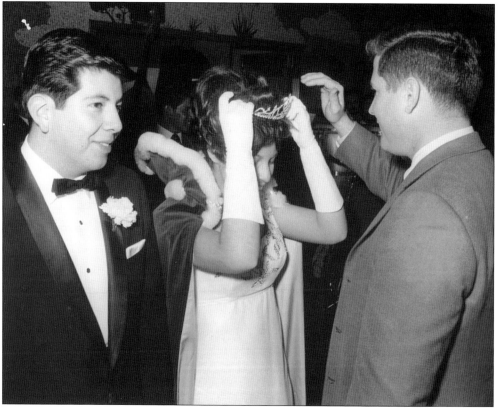

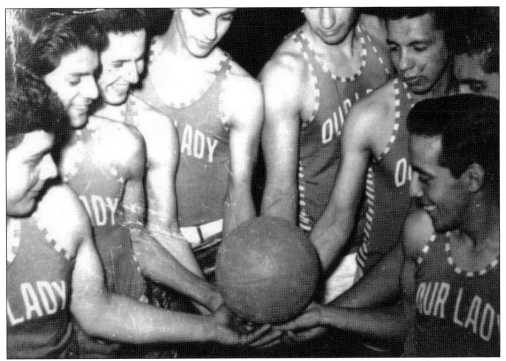

Since the days when Father Giles coached basketball, Our Lady of Perpetual Help was a sports hub for local Mexican American families outside of worship and school. Here, a basketball team poses in the 1940s. In addition to the church, Cudahy also supported these athletic events. (Courtesy Natalie Castro Olmsted.)

The baby boom and prosperity of the 1950s and 1960s enabled Our Lady of Perpetual Help to dedicate a new sanctuary in 1958. This was the setting for this first communion class that includes Father Knute, Rozanna Mendoza, Hope Chavez, Diana Diaz, Sharon Martines, Andrew Martinez, Robert Melchor, Gil Ornelas, Victoria Ornelas, Carlos Sanchez, and Ronnie Alfaro. (Courtesy Cinthia Ornelas Avilar.)

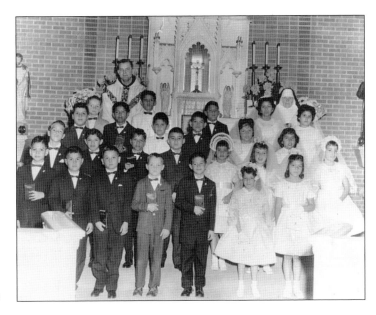

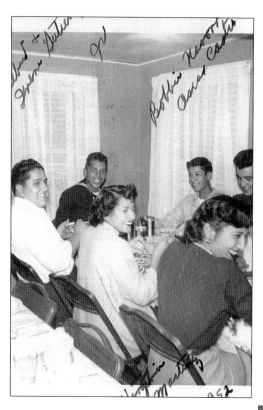

Young men from the North End also served in Korea and Vietnam. Here, Junior Sanchez, in his US Navy uniform, enjoys a welcome home meal. In the foreground, from left to right are Gilbert Guiterrez, unidentified, and Virginia Martinez-Mendoza. In the back, from left to right are Junior Sanchez, Bobbie Navarro, and Oscar Castro. (Courtesy Anita Mendoza.)

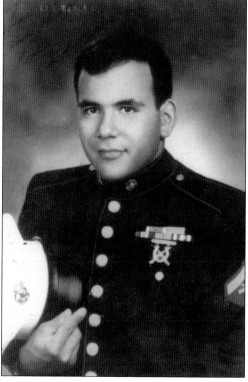

Robert Bobby Murguia enlisted in the US Marine Corps, serving in Vietnam with the 2nd Battalion. He saw action at the battle of Khe Sanh, and in 1968, came home after his third Purple Heart. He later went on to serve as an officer with the Wichita Police Department. (Courtesy Bobby Murguia.)

Serving in the military is often a multigenerational experience for Mexican American families. In the image at right, little Tony Oropesa Jr. is in the arms of his grandfather Isaac Hernandez. Tony's father, Antonio, landed at D-Day. Antonio Jr. served in Vietnam. (Right, courtesy Carolyn Benitez and El Huarache Project Collection, Special Collections and University Archives, Wichita State University Libraries; below, courtesy Rosalie Rosales de Lopez.)

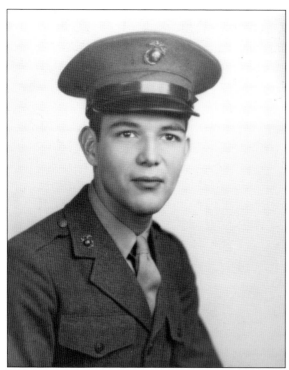

Military service after World War II did not always involve serving in actual combat. Joe Roman Jr., the son of José and Andrea Roman, joined the US Marines and was stationed in Asia. He returned to Wichita, where he worked as a carpenter. (Courtesy Amelia "Tillie" Roman Ornelas.)

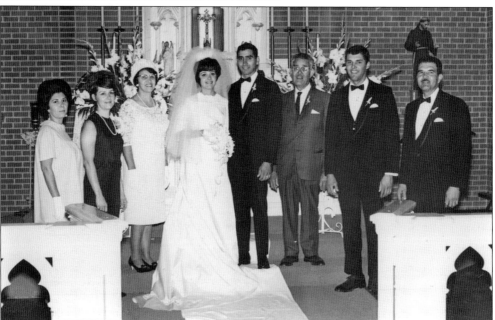

Social events such as weddings illustrate the growth of the middle class in the 1950s and 1960s. Although not all Americans profited equally from this prosperity, some households in the North End joined the middle class. From left to right are Amelia "Tillie" Roman, Sally Roman, Andrea Roman, Dolores "Lola" Roman, John Torrez Jr., Joe Roman Sr., William "Billy" Roman, and Joe Roman Jr. at Our Lady of Perpetual Help Catholic Church on October 14, 1967. (Courtesy Amelia "Tillie" Roman Ornelas.)

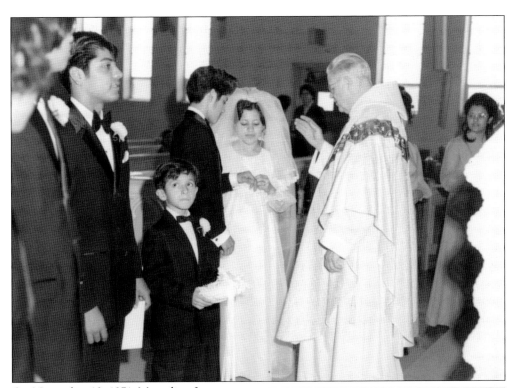

On November 13, 1971, Marcelino Joe Chavez Jr. and Alice Irene Ornelas were married at Our Lady of Perpetual Help. (Courtesy Marcelino Chavez Jr.)

Cirilo Arteaga's legacy included working as a caddy at the Wichita Country Club, serving in World War II, a career in the US Postal Service, and a role as an active community leader whose efforts included the GI Forum, La Familia Senior Center, and the Nomar International Market. His recollections about the North End barrios were among the first accounts of these communities. (Courtesy Carolyn Benitez and El Huarache Project Collection, Special Collections and University Archives, Wichita State University Libraries.)

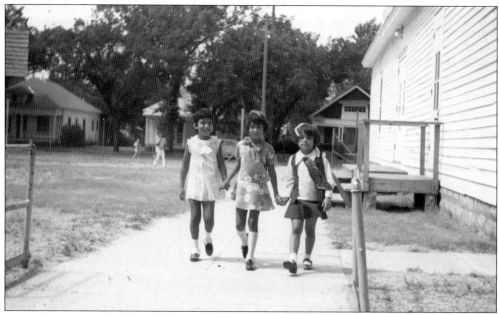

From left to right, Lisa, Marjean, and Melissa Ornelas are on their way to Waco Elementary School on Melissa's first day of Kindergarten. (Courtesy Brenda Ornelas McKellips.)

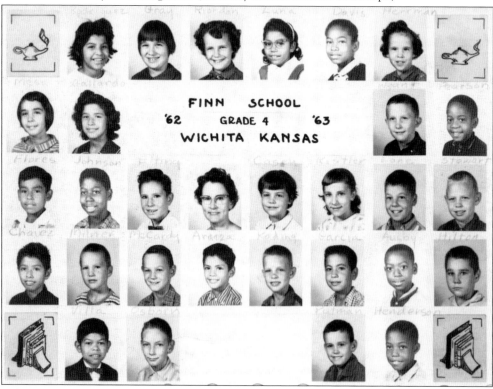

While students of color faced segregated high schools, the elementary and middle schools served black, Mexican American, and white students, as this fourth-grade class photograph from Finn Elementary School in 1962 shows.

Clara Sandoval and her son David sit on the front porch of the family home at 2745 North Fairview Avenue, which was on the northern edge of the North End community at the time. (Courtesy David Sandoval.)

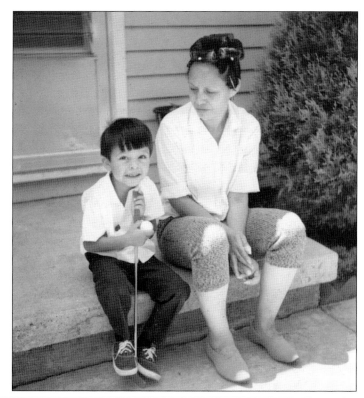

Not all Latino families in Wichita immigrated from Mexico in the early 1900s. This Martinez family, for example, is tied to the old Hispano families of northern New Mexico. The family migrated to Liberal, Kansas, where this photograph was taken in 1957. From left to right are Virginia, Sherrie, Carmen, Ray, and Mike Martinez. The family later relocated to Wichita, living on North Wellington Place. (Courtesy Todd and Lisa Duran.)

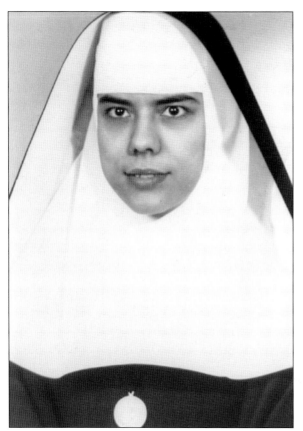

Aurora Mendoza, later known as Sister Julietta, SSM, became general superior of the Congregation of the Sisters of the Sorrowful Mother. While the Catholic Church in the United States has experienced a decline in attendance in the last few decades, the overall percentage of Catholics has not changed thanks to the growth of the Latino population. (Courtesy Anita Mendoza.)

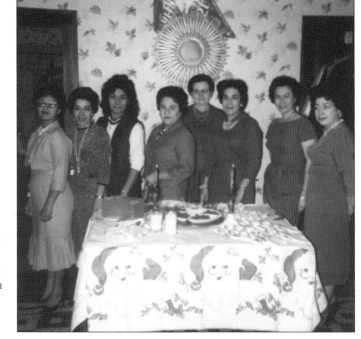

The years after World War II were a heyday for organizations such as the Pan-American Club. A social as well as civil rights organization, the GI Forum also hosted luncheons. (Courtesy Amelia "Tillie" Roman Ornelas.)

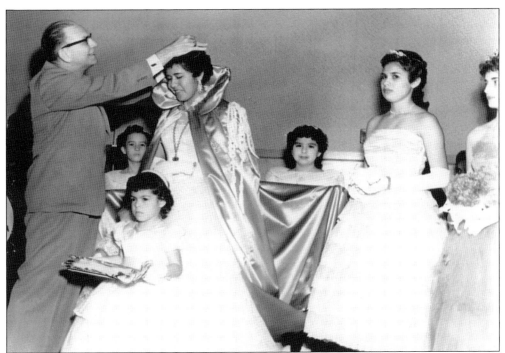

The GI Forum queen candidates sold tickets as a fundraiser for scholarships and legal costs of the organization. The candidate who sold the most tickets became the queen of the GI Forum. The winner was announced at the forum's dance. Celebrations such as September 16, which had been a celebration of Mexican national identity, were shifting to focusing on civil rights issues. The forum also maintained an important social role, such as the dinner pictured below. (Above, courtesy Carolyn Benitez and El Huarache Project Collection, Special Collections and University Archives, Wichita State University Libraries; below, courtesy Juanita Lepe.)

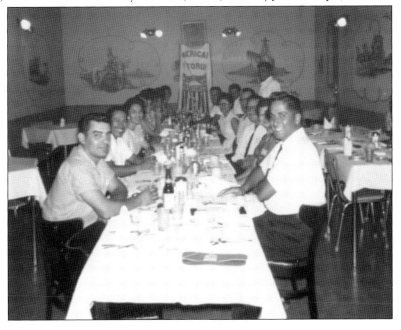

Constructed in 1925, the bathhouse at North Woodland Park (seen here in the background), with its pool adjacent, was popular—and segregated. At first, Mexican workers who helped build and maintain the facilities were not even allowed to swim there, and when several of them protested, they were allowed to swim but only just before the pool was drained. (Courtesy Wichita Parks and Recreation.)

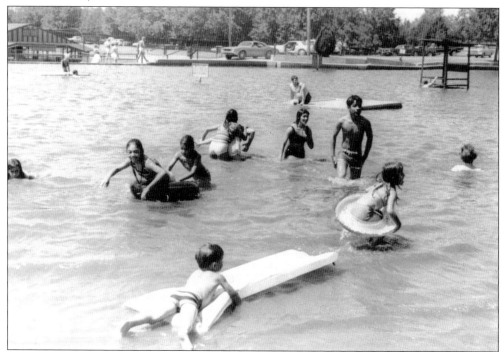

Families in Wichita maintained ties with relatives and others in the Mexican American community in places like Newton and Wellington. Here, the Ornelas family enjoys a swim at Courtney Davis Lake near Newton. (Courtesy Brenda Ornelas McKellips.)

Like several Wichita youth, Russ Oropesa went into the rock scene, becoming a member of groups such as Harley Zurlett and Southwind. Here Oropesa, who went by "Big O," performs at an outdoor concert at Herman Hill Park. (Courtesy Russ Armitage.)

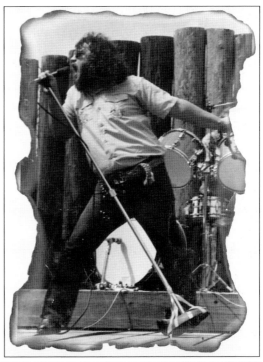

Mexican American rock musicians included North High students Art Martinez and Mike Jimenez, who played with Doug and the Inn-Truders. South Side bands included Montezuma's Revenge, featuring Paul Chavez on bass and Danny "Bubba" Martinez on vocals. Here, the Gateway Bar, next to Connie's, hosts the band The Other Side, whose members included Eddie Jaso, Rene Ornelas, Jessie Robledo, and Jessie Medina. (Courtesy Carolyn Benitez and El Huarache Project Collection, Special Collections and University Archives, Wichita State University Libraries.)

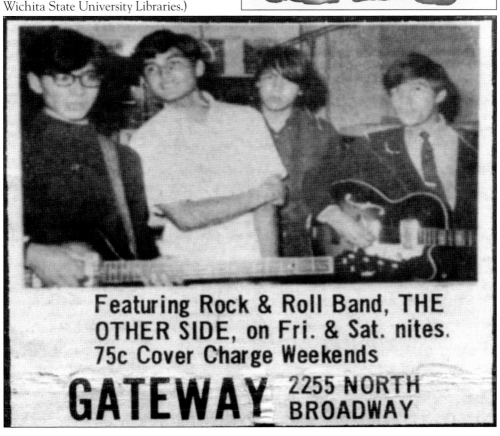

Featuring Rock & Roll Band, THE OTHER SIDE, on Fri. & Sat. nites. 75c Cover Charge Weekends
GATEWAY 2255 NORTH BROADWAY

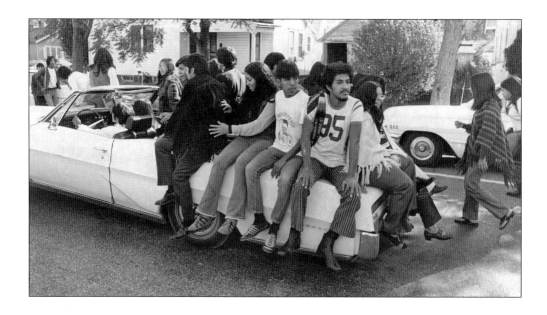

Here, Chicano students from Wichita State University, North High School, and Horace Mann walk out of class in protest for equality and civil rights on September 16, 1971, during the second annual Chicano Mexican Independence Day march. Vic Rizo is driving his brother Chico Rizo's 1967 Pontiac Bonneville low rider. Jeanne Mendoza and Veronica Luna-Casados of WSU's Mexican American Student Association organized the event. The man in the "95" shirt, Carlos Rizo, is next to Marci Arguelles and Stella Guiterrez. Suzette Santiago is walking behind the car. Below, Buster Sanchez, in the hat, takes part in the march. (Both, courtesy of Jeanne Mendoza.)

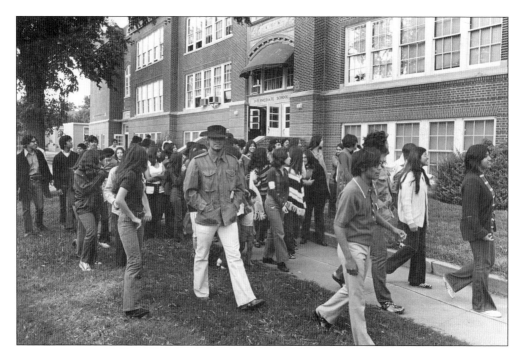

In the late 1960s, an organization called the Mexican American Student Association was formed at Wichita State University to advocate for Latino issues on campus and in the community with Eddie Tejeda as the first president. During the 1970s, they brought in speakers such as José Ángel Gutiérrez, founder of La Raza Unida Party in Texas. At right, from left to right are Veronica Luna-Casado, Art Mendoza (in back), and Rosario Del Castillo with Adela Martinez outside the student union theater. A few years later, the movement became part of the national Movimiento Estudiantil Chicano de Aztlán (Chicano Student Movement of Aztlán). Based on a tradition that the Aztecs came from a land to the north called "Aztlan," Chicanos identified not as immigrants, but rather as the area's original indigenous inhabitants. (Right, courtesy of Jeanne Mendoza; below, courtesy WSU Special Collections.)

"ATZLAN LIBRE"
SOFTBALL TOURNAMENT
16 de Septiembre WICHITA Tournament of Champions
'ATZLAN LIBRE' TOURNAMENT/DISCO
Eagles Lodge

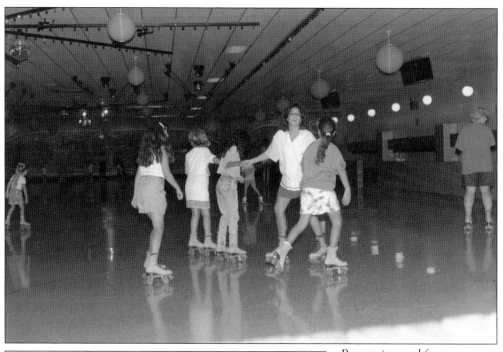

Recreation and fun were a part of North End life, from dances and fiestas to family outings. Here, a birthday party in 1988 is celebrated at Skateland North. (Courtesy Teresa Mora.)

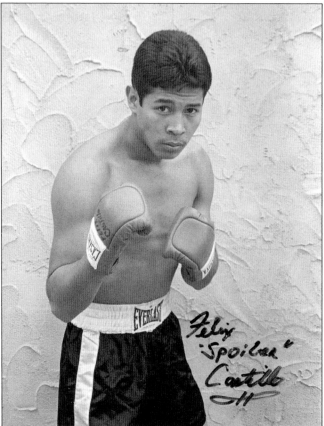

Felix Castillo Jr., at 19 years old, was a member of the 1980 US Olympic team that boycotted the Olympics due to their being held in the Soviet Union. Boxing has been a part of the North End since the 1920s, with clubs such as the North End Boxing Club, the Villa Boxing Club, and Hernandez Boxing Club. (Courtesy of Israel Villa.)

92

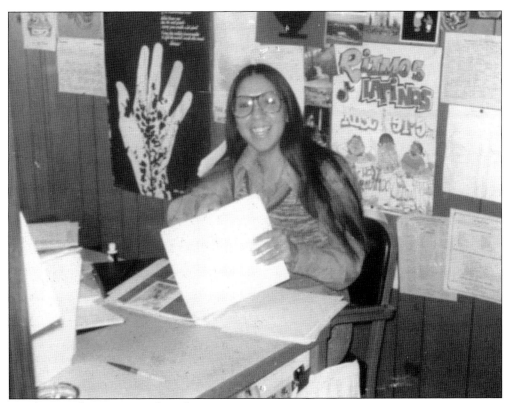

Carolyn Rosales Benitez graduated from college in 1977 and became involved in local activism efforts, including programs to feed the elderly in the community. She is pictured here in her first job with the private nonprofit SER corporation's Jobs for Progress. Later, she became the face of La Familia Senior Center. (Courtesy Carolyn Benitez.)

In the 1970s, SER focused on providing job opportunities to Hispanics and launched the Spanish language journal *El Conquistador*. Journals such as this served both older residents for whom Spanish was their first language as well as a new wave of immigrants from Mexico who had started to arrive in Wichita. (Courtesy Mike Rosales.)

PROGRAMA GRATIS

PREPARACION PARA TRABAJAR
Cuando busque trabajo, ¿cómo se refleja usted a los empleadores? En la clase de preparación, usted se puede ver y escuchar sus entrevistas en la televisión, aprender de los lugares en donde buscar trabajo, de sus derechos civiles, y más.

PREPARACION ACADEMICA
Los que no se graduan de la secundaria ganan menos al año de los que se graduan. Un diploma de educación basica (G.E.D.) puede mejorar lo que vd. gana con sólo 12 semanas de clases. Seguramente, vale la pena.

ENTRENAMIENTO EN EL TRABAJO
Los contactos que tiene SER con las compañías de Wichita pueden proveer un lugar en dónde se puede aprender una carrera mientras que gane dinero Cuando termina tendra un sueldo mejor y experiencia en esa profesión.

ENTRENAMIENTO DE HABILIDADES
Tenemos ayuda financiera para entrenamiento en áreas de mecánica, a medicina. Nuestros consejeros le ayudarán a escoger los mejores cursos y escuelas, y le daran apoyo en su trabajo después. Por supuesto los que tienen habilidades especiales ganan más.

SER/JOBS FOR PROGRESS, INC.
121 East 21st St. 265-0791
SER/JOBS FOR PROGRESS, INC. is a subcontractor under the City of Wichita's Comprehensive Employment Training Program funded under a CETA Grant from the Department of Labor. AN EQUAL OPPORTUNITY EMPLOYER

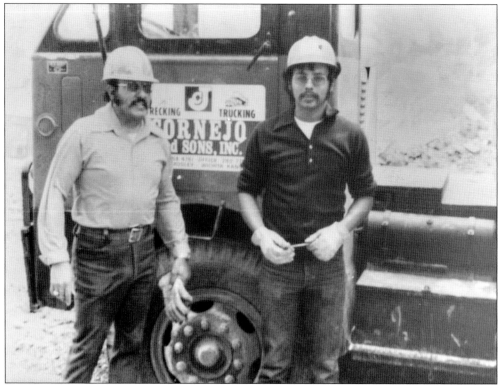

The son of immigrants, Jess Cornejo started a trucking and excavating company in 1952. By the 1970s and 1980s, the company became Cornejo & Sons with Jess's five sons helping run and expand the business into construction, demolition, waste hauling, and asphalt. Here, Jess and son Ron appear in front of one of the company trucks. (Courtesy Cornejo Construction.)

Concha Casanova, on the left, meets with relatives at Riverside Park, the site of many local family gatherings. Other locations for events included Woodland Park on Twenty-First Street, and to the north, Heller's Grove on Arkansas Avenue. (Courtesy Linda and Lydia Santiago.)

Changing demographics resulted in changing businesses. By the 1970s, Alberto Granados transformed the Crow and Son Grocery Store at Twenty-Second and Jackson Streets into one of the area's first tortilla factories. (Courtesy Mac Orsbon.)

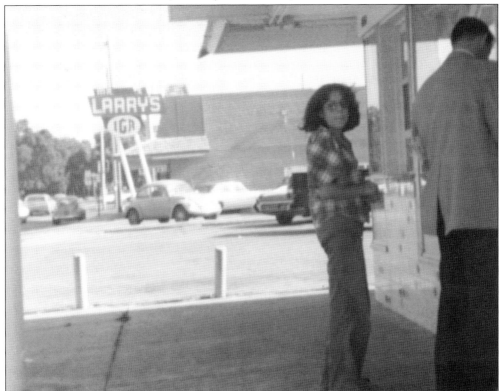

Teresa Mora waits for her order at the Dairy Queen at Twenty-First Street and Arkansas Avenue. Larry's IGA is in the background. (Courtesy Teresa Mora.)

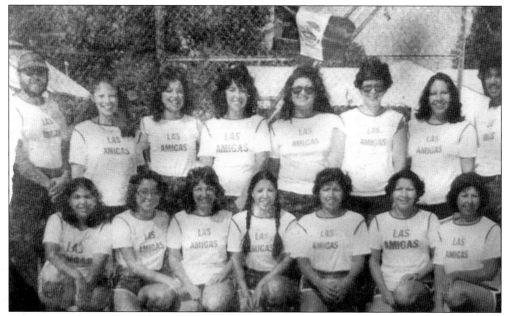

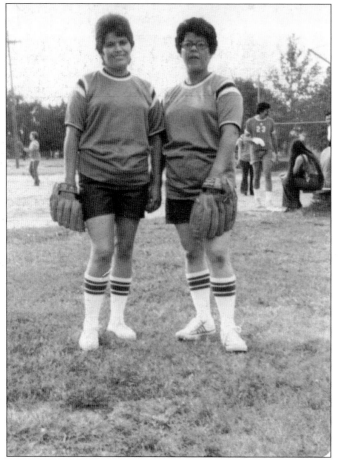

Sponsored by Connie's Mexican Cafe, the team known as Las Amigas included, from left to right, (first row) Annette Rosales Chavez, Anna Navarro, Maria Balderas Rosales, Carol Rosales Benitez, Teresa Rosales Vasquez, Diane Mitchell Acosta, and Juanita Rosales Lepe; (second row) coach Leo Lopez, Carmen Lopez, Chris Navarro Alonzo, Sylvia Hernandez Martinez, Donna Ornelas Sanchez, Beverly Murgia, Ana Garcia, and assistant coach Lawrence Rosales. (Courtesy Rosalie Rosales de Lopez.)

Softball was a family event for some. Here, Virginia Guana-Martinez (right) and Phillis "Lipa" Gauna are on the playing field. Virginia's son Daniel "Bubba" Martinez also played softball. (Courtesy of Daniel "Bubba" Martinez.)

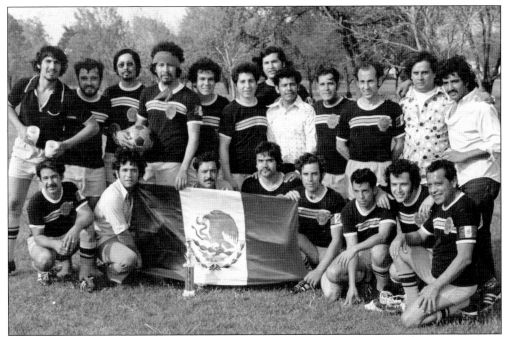

Soccer is the most popular sport in Latin America. Some local teams, such as Anáhuac (see page 44) were active in the 1920s, when *fútbol* was the second-most popular sport in the United States behind only baseball. As Mexican Americans started reconnecting with their heritage in the 1970s, soccer teams, like the one pictured here, flourished. (Courtesy David Sandoval.)

This Aztecas baseball team kept alive a name that went back to the 1920s, with different hairstyles. From left to right are (first row) Al Arambula, Frank Martinez, Chris Torres, Ricky Tejeda, Ralph Cabrera, Harvey Del Castillo, and Louis "Sleepy" Ramirez; (second row) Danny Chavez, Bernie Jauregui, Madrid Jauregui, Dino Castro, George Onteberos, Ray Aguirre, David "Mellow" Sanchez, and Chris "Gator" Palacios. (Courtesy Daniel "Bubba" Martinez.)

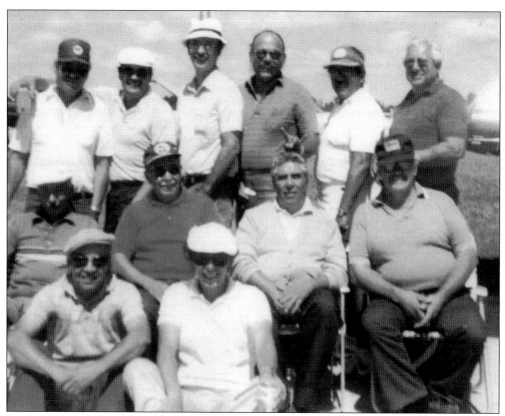

Young men started working to support their families by being caddies for the Crestview Club. This also gave the caddies a chance to play golf in a place where they could not have been members. Some of these young men, such as Auggie Navarro, Joe Minjares, and Eli Romero went on to win city championships. Some carried a love of golf all their lives, forming the basis of a golfing club known as Los Patos, or "the Ducks." The original group included Oscar Castro, Louis Castro, Manual Diaz, Tony Diaz, Mike Diaz, Julius Mendoza, and Pete Padilla. Later additions included Mike and Lupe Rosales, Louie Saiz, James Hernandez, Joe Tejeda, Nacho Guerrero, James Iniguez, Jess Chavez, Al Gutierrez, and Manny Martinez. (Both, courtesy Natalie Castro Olmsted.)

In 1970, L.D. Diamond opened his new Standard filling station at Thirteenth and Market Streets with son Larry appearing in a clown costume. Little did anyone know that this was the swan song for the North End. As meat packing moved west to the feedlots of western Kansas and the Oklahoma Panhandle, business at the packinghouses declined. Cudahy closed its Wichita plant in 1976. Dold relocated its facilities. The Stockyards Hotel and Restaurant burned in 1973. The stockyards closed in 1980 and the exchange building was torn down. The refinery closed in 1993. The new Interstate 135 ran along the route of Chisholm Creek and business along US Highway 81 dried up. Stores that once served nearby families were boarded up or found new purposes. (Above, courtesy Linda Stoner.)

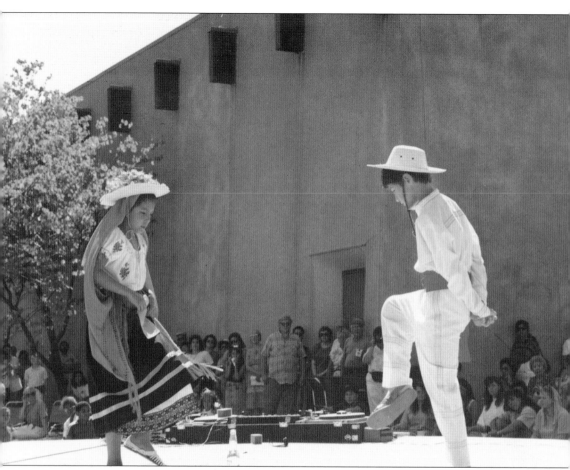

In the 1970s, the City of Wichita constructed a new recreation complex at Twenty-Seventh Street and Arkansas Avenue called Evergreen. Adjacent to Cloud Elementary, the facility included a pool, public spaces, and outdoor ball fields. It became the site of community events such as fiestas. Here, two dancers from the Los Niños de Norte group perform at a 1988 fiesta at Evergreen. Events such as these remained popular. The family of Joe Tejeda was able to finance their children's educations thanks to the proceeds from the food they sold, based on old family recipes. (Courtesy Teresa Mora.)

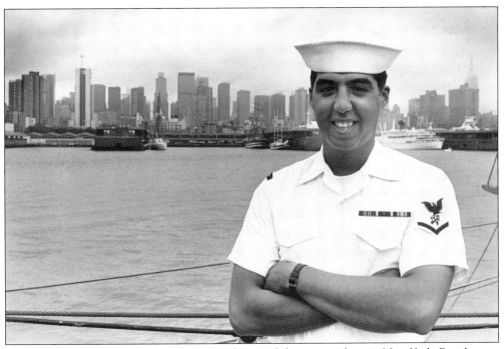

Representing the next generation, Ron Rosales stands here in uniform in New York. Rosales was later elected to the board of USD 259. (Courtesy Ron Rosales.)

Known as the "Three Ms," from left to right, Margie Chavez Sanchez, Mary Hernandez, and Mary Jo Stang were known for their presence in the community, as well as for their role in the Our Lady of Perpetual Help fellowship dinners. (Courtesy Marcelino Chavez Jr.)

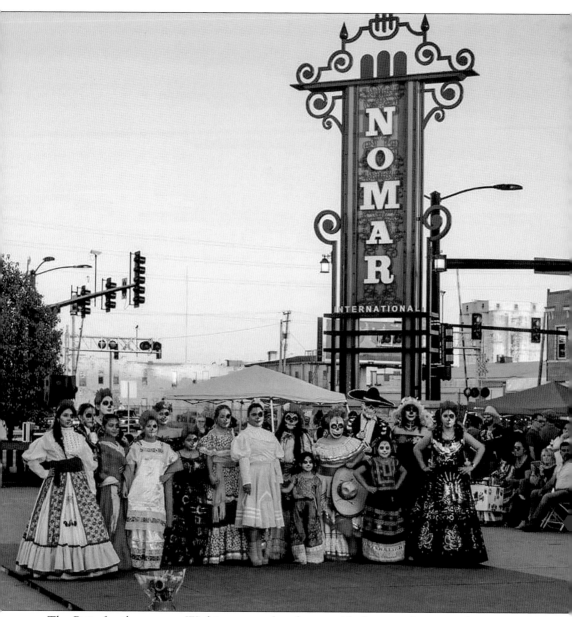

The Peña family came to Wichita over a decade ago with dreams of owning their own tire-changing business. They were successful and decided to open a traditional Mexican boutique. In this photograph, a group from the Azteka's Boutique, with beautiful traditional Mexican gowns, celebrates Día de los Muertos, or "Day of the Dead," at Nomar International Plaza. (Courtesy Frank Acevedo.)

Four

EL PUEBLO

By the 1980s, the North End was an area in transition. The industries that had provided a reliable source of jobs had moved on. Many children and grandchildren of the North End now lived across town or across the country. The neighborhood began to age as younger generations, whether white, black, or Mexican American sought better fortunes on the city's edges. *Abuelas* and *abuelos* who lived in the little houses north of Twenty-First Street found fewer stores and resources nearby.

Meanwhile, new migrants from Southeast Asia and Latin America brought with them very different ways of life from those of residents just a generation earlier. Some of the older families worked to integrate these newcomers into the community through a range of social services. Others felt that new families were not working hard enough to assimilate as their parents and grandparents had. By the 2000s, the North End had gone from a working-class industrial hub to an international and multicultural part of the city. A part of Wichita once defined by the stockyards and packinghouses became known for its Mexican restaurants, quinceañera apparel stores, and Buddhist temples.

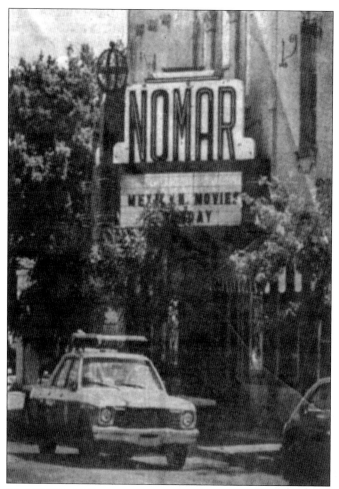

The Nomar Theater has in many ways symbolized the story of the North End. It emerged to serve the North End's working-class families. Older Mexican Americans remembered being segregated to the balcony. Those who came of age by the 1960s remembered an integrated theater that was a local hangout. By the 1970s, it became known for X-rated movies, Kung fu reruns, or films in Spanish. For many years, the old theater functioned as a storage facility, and now plans are in the works to restore it as a community center. (Left, courtesy Carolyn Benitez and El Huarache Project Collection, Special Collections and University Archives, Wichita State University Libraries; below, courtesy David Dinell.)

Senior services became necessary as younger generations were too busy working and Wichita's lack of public transportation kept seniors from accessing services downtown. In the 1970s, federal programs on aging emerged and the first services took place at Our Lady of Perpetual Help, seen here. (Courtesy Carolyn Benitez.)

One of the few surviving buildings from the heyday of the packing plants is the 1910-era Wichita Manual Training School Association hall at Twenty-First and Topeka Streets. The site of dances and other community events, it even had a swimming pool. In 1918, it served as a hospital during the influenza epidemic, but later on, its swimming pool was converted for the processing of hides from across the street.

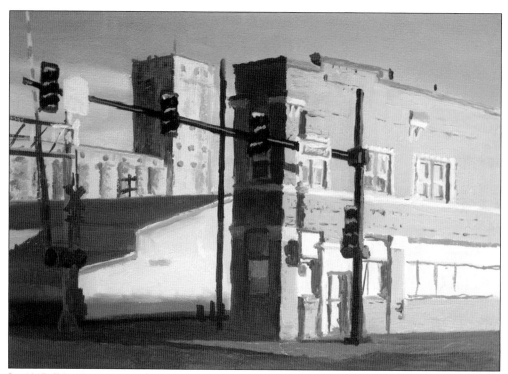

In 1917, E.L. Craig erected a two-story structure on land between Lawrence Avenue and the railroad tracks that became the home of the Stockyards State Bank. Designed to fit a wedge-shaped parcel of land, the building was narrow at one end and wider at the other and has been known as the Flatiron Building since its construction. Artist Bill Goffrier depicted the Flatiron Building in his oil painting *201* from his Authenti-City Series. The buildings at the other end of the block housed one of the first Mexican supermarkets, El Super del Centro, whose ghost sign still marks the original location. (Above, courtesy Bill Goffrier.)

Southeast Asians started coming to Wichita in the 1970s and 1980s following turmoil in Indochina. A number of families established their own network of businesses and associations on North Broadway. Thai Binh, now on West Twenty-First Street, is the biggest Asian grocery store in Wichita; it opened its doors in 1985 on Twenty-First and Broadway.

By the 1980s, the old businesses that once served the North End's working-class families closed or moved. The vacant buildings started taking on new tenants and new uses. In 1980, Wichita's local public television station, KPTS, moved into the former Western Auto building on Twenty-First Street.

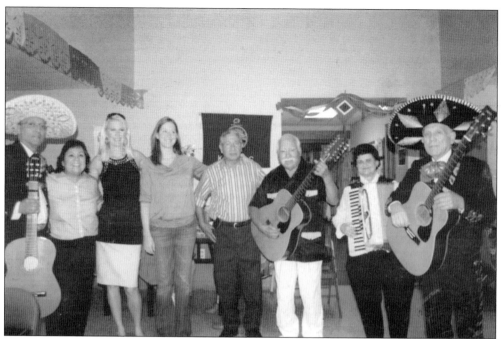

Church renovations required senior programs to move and a grassroots movement went to the city in 1989 to transform the former bathhouse of Woodland Park into La Familia Senior Center. Serving seniors from a range of ethnic and racial backgrounds, La Familia has provided a range of social, health, and educational services. Below, from left to right, Margo Parks, Raymond Reyes, Joe Rodriguez, Melissa Rodriguez, and Tony Madrigal appear at a fundraiser for the center. (Above, courtesy La Familia Senior and Community Center; below, courtesy Natalie Castro Olmsted.)

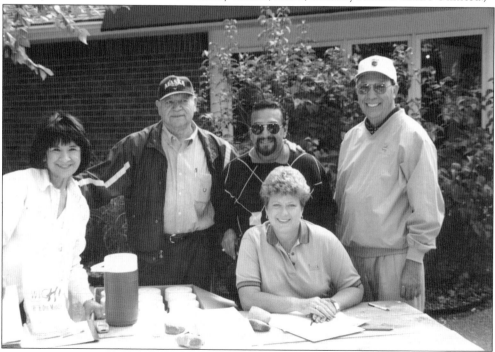

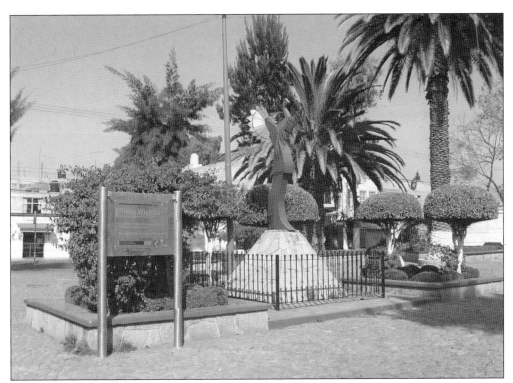

In 1973, Tlanepantla, a highly industrialized city north of Mexico City, and Wichita became sister cities, a relationship ratified in 2008. Here, the Plaza Wichita in Tlaneplanta stands with a small replica of the Keeper of the Plains, donated by the City of Wichita. Two of the four Wichita sister cities are in Mexico, with Cancun being the second. This reflects the growing weight and influence of the Mexican heritage in the city. (Courtesy Leigh Thelmadatter.)

Guadalupe "Lupe" Magdaleno stands behind her mother, who visited her from Mexico for the first and last time. Magdaleno became the executive director of Sunflower Community Action, a nonprofit organization founded in 1991 to engage in issues from neighborhood development to immigration advocacy. (Courtesy Guadalupe Magdaleno.)

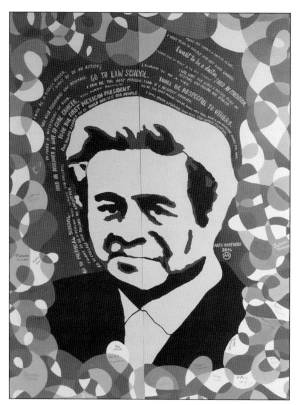

In 2021, Wichita's USD 259 constructed a facility on the site of the old Arkansas Avenue Elementary School and named it in honor of Martin Ortiz. Born in El Huarache, Ortiz was dismissed as "retarded" for not being able to speak English well but later founded Whittier College's Center of Mexican American Affairs in 1968. It was the first school in the city named after a Mexican American.

In 2013, Armando Minjarez and Latino leaders from South High created the mural *Immigration is Beautiful* at Twenty-First and Park Place, using a mix of American and Mexican iconography to highlight both the struggles and opportunities that come with immigration. (Courtesy Armando Minjarez.)

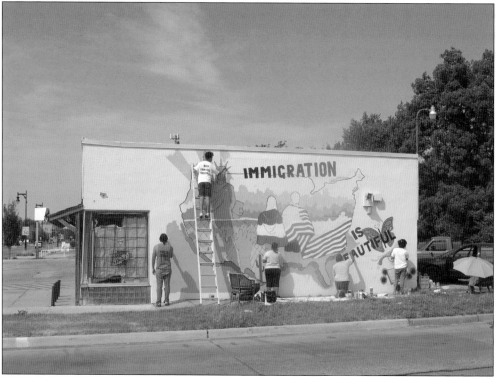

New families adapted the landscape of the North End. Homes from the early 20th century gained colorful facades, stuccoed walls, and fenced-in yards. To preservationists, this adaptation is an uncomfortable transformation. To those who embrace Latino urbanism, however, these changes give a neighborhood a new lease on life.

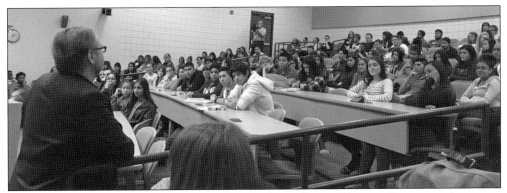

Given its Latino enrollment, North High has had a tradition of hosting Latino speakers since Rodolfo "Corky" Gonzales, one of the main figures of the Chicano movement, visited in 1971. Here, Mexican American author Luis Alberto Urrea talks with students at North High about his novel *Into the Beautiful North*, the book selected as Wichita Public Library's Big Read in 2015. (Courtesy Luis Alberto Urrea.)

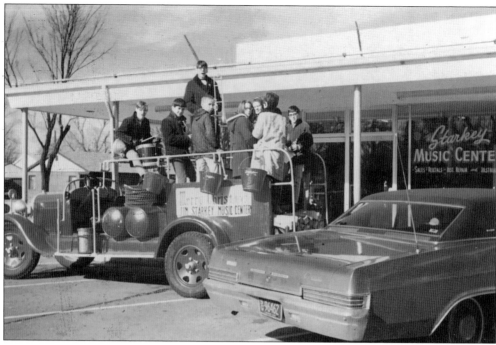

Jim Starkey, owner of Starkey Music Center, acquired this historic fire truck from Longton, Kansas, and in the 1960s became known in the community for driving it in local parades. After Starkey died in 1998, his son Dee continued the business until it closed in 2014. (Courtesy Dee Starkey.)

David Sandoval's food truck stands in front of Sweet P's in the old Riverside Village shopping center that once housed Starkey Music Center. Sandoval sells Wichita-style Mexican tacos, with ground beef mixed with peas and carrots. The popularization of food trucks in the early 2010s was also present in Wichita. Several of them operated in the North End, offering Mexican specialties such as pollo asado or churros.

Many newcomer families started small businesses in the new century. Javier and Liliana Villegas arrived in Wichita over a decade ago and worked as insurance agents at the Juarez Plaza on Waco. Later they founded an independent insurance agency, Family First. They are pictured here with the Raíces de Mi Tierra Ballet Folklórico and singer Dysi Sosa at the opening party of their new office at Twin Lakes Shopping Center.

Specialty shops such as *panaderías* (bakeries), *carnicerías* (butcher shops), or *paleterías* (popsicle shops) are usually located in long-standing Hispanic neighborhoods. They help local communities preserve their culinary traditions. In the picture, two employees of Juarez Bakery hold a *rosca de reyes* (three kings cake), which is eaten on January 6 to celebrate the Christian feast day known as Epiphany. (Courtesy Migrant Kitchens Project.)

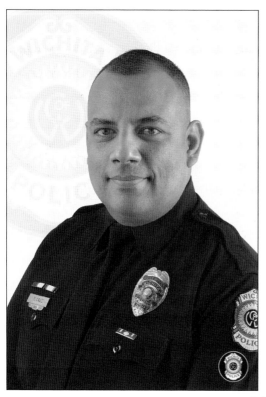

Mexican Americans from the North End have been involved in the legal field and law enforcement for generations. Names like Hernandez and Bribiesca have become well known as lawyers and judges. Meanwhile, several served the community through the Wichita Police Department. Pictured here are public information officer Paul Cruz (left), who has been a liaison to the Latino community for over a decade, and deputy chief of the investigations division José Salcido, who has served over 25 years in the department. From California, Cruz was surprised to learn that he had relatives who had lived in Wichita long before he came to the city. (Both, courtesy Wichita Police Department.)

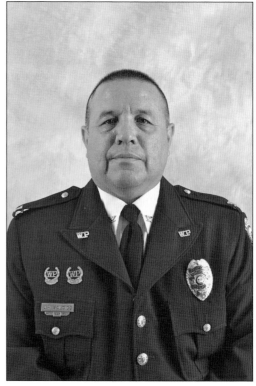

During a kitchen remodel at Connie's, workers found a previously covered and forgotten mural that probably dates to the 1950s. A fragment survives today at Connie's. (Courtesy Connie's and Adele Garcia.)

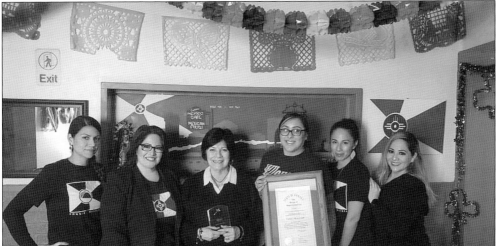

Carmen Rosales, center, stands with a certificate that celebrates the legacy of Connie's. On her left in this image is Delia Garcia, who went on to represent this district in the state legislature. Carmen once recalled she had once forgotten most of her Spanish but "for some weird reason, subliminally, it came out. It was the only way I could communicate with the cooks." (Courtesy Delia Garcia.)

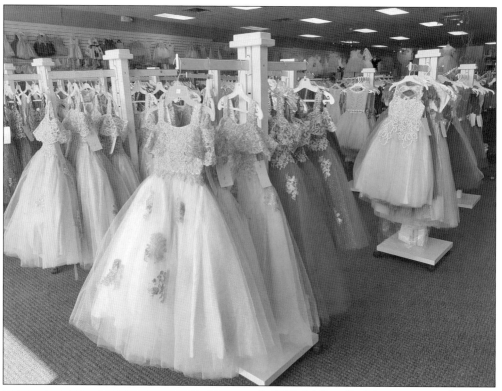

In 2009, Melissa Rodriguez was a student at Wichita State University, and at the last minute, submitted her business plan for a shop that sold quinceañera dresses to a school entrepreneurship competition. She was floored to find that she won the competition. She was the first minority and first woman to do so. This formed the basis of her business, Rodriguez Fashions.

The first generations of Mexican American Wichitans patronized many of the same stores and businesses as the larger Anglo population. Recent immigrants from Latin America, however, have brought with them a new range of local businesses that serve regional foods, support ceremonies such as quinceañeras, and feature Mexican imagery such as the Virgin of Guadalupe.

With the growth of the Latino population in South Wichita, the Kansas City–based chain Rio Bravo decided to open its first Wichita supermarket in 2019 on South Seneca Street. Two years later, a second store was inaugurated at the historic Twin Lakes Shopping Center, on Twenty-First Street and Amidon Avenue.

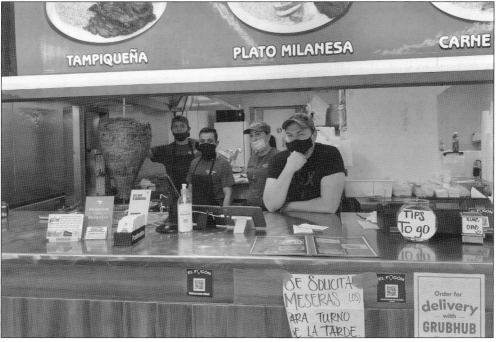

Initially, ethnic businesses started in the North End and spread out to the rest of the city. By the 2000s, however, there were enough Latino businesses across the city that they started on the South or West Side and expanded into the North End. For example, Taqueria El Fogon began in 2015 on Bluffview Drive and Harry Street on the South Side and then expanded to Twenty-Fifth Street and Arkansas Avenue in 2018.

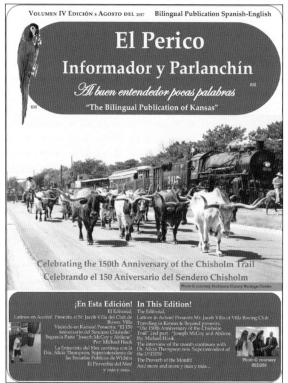

A program from KMUW called La Máquina Música demonstrated that there was a Spanish-language audience in Wichita large enough to support a radio station. To meet that demand, in 2002, Journal Broadcast group, the owner of the local KYQQ, transformed the station into Radio Lobo. Since then, another station, KHTL, was transformed into a Spanish station by Air Capitol Media Group in 2015. (Courtesy Radio Lobo.)

There were two newspapers in the North End that went by the name of *El Perico*. The first, in the 1970s, came from the United Methodist Urban Ministry and often featured local writers. In 2013, Marco Alcocer founded a second *El Perico* to serve as a bilingual publication that joined a growing Spanish-language media presence in Wichita that included Univision and Telemundo. (Courtesy Marco Alcocer.)

In 2006, Janiece Baum Dixon grew tired of the graffiti that marked her family's building on North Arkansas Avenue and commissioned Wichita State University artist Kathy Hull to design a mural that depicted the Mexican celebration of the Day of the Dead. By 2018, time had taken its toll on the mural and Dixon commissioned graffiti artist Daniel Guatimea (who goes by Areone LA) to create a new mural. While different in style, both murals celebrated the power of Latina women in shaping life in the North End. (Above, courtesy Linda Stoner.)

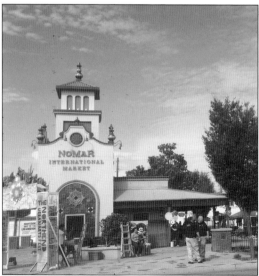

Wichita's leaders have tended to see the North End as a problem to be solved. Proposed solutions usually involved publicly funded construction projects that replaced "blight" with modern structures. Meanwhile, residents have grown wary of new plans, in spite of affirmations that "it will be different this time." In the 1989 plan above, a redesigned Twenty-First Street would have run underneath the tracks past Broadway. An early 2000s plan proposed a larger indoor farmers market–type space called the Nomar International Market. In the wake of the 2008 economic downturn, however, a smaller-scale development that was more of an outdoor space opened in 2011. (Above, courtesy Sedgwick County Metropolitan Area Planning Department.)

Families keep celebrating their Hispanic heritage with Día de los Muertos, folkloric dances, and *matachines* performances, such as the one shown below. These children represent Wichita's future. The school district of central Wichita, USD 259, celebrates its diverse student body with the phrase "The World Walks our Hallways." Today, nearly 37 percent of the student body identifies as Hispanic. (Right, courtesy Frank Acevedo; below, courtesy Anita Mendoza.)

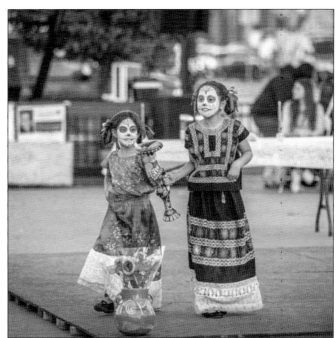

Current plans are for the Evergreen branch of the Wichita Public Library to be redeveloped into a social center for the area. Raymond Olais designed the pillars out front as well as details from the Nomar International Market. (Courtesy Ariel Rodriguez.)

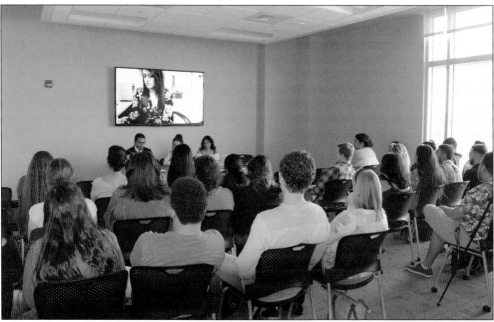

North End residents Tony Ibarra (left) and Emira Palacios (right) discuss their experiences as migrants in an event in 2018. Brought to the United States as a child, Ibarra is a DACA beneficiary and graduated with a mechanical engineering degree. Activist and educator Palacios arrived in the United States in the 1980s, and it took her over 20 years to adjust her immigration status. (Courtesy Migrant Kitchens Project.)

The North End has had a long connection to athletics. The neighborhood was home to two Olympic boxers. One was Felix Castillo Jr. (pages 77, 100), and the other was Nico Hernandez, a bronze medalist at the 2016 Olympics. (Courtesy Janiece Baum Dixon.)

Gene and Yolanda Camarena stand with Ariel Rodriguez of Empower Evergreen to turn the old Nomar Theater, closed since 1983, into a new community center. Local entrepreneurs, Gene had a Pizza Hut franchise and Yolanda received her MBA from Harvard University. (Courtesy Carla Eckels and KMUW.)

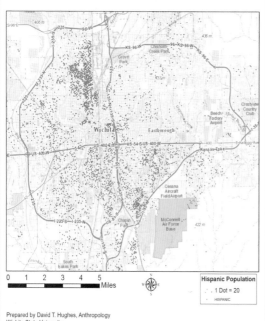

Hispanic Population in Wichita, KS 2010

Hispanic Population
. 1 Dot = 20
HISPANIC

0 1 2 3 4 5 Miles

Prepared by David T. Hughes, Anthropology
Wichita State University

By the early 2000s, the US Census revealed that people of Hispanic origin were over 17 percent of the city's population. The North End has the most visible concentration of these households, although Latinos live across the city, with significant clusters in southeast and southwest Wichita. More than just Mexican, these communities have included Central Americans such as those from El Salvador and Guatemala as well as South Americans from Peru and Puerto Ricans and Cubans from the Caribbean. This diverse population of Hispanic origin has manifested itself in an increasing numbers of events that celebrate Latino identity. For example, a parade and performances of different national dances, among other activities, took place in September 2021 in Old Town as part of Latin Fest ICT. (Left, courtesy David Hughes; below, courtesy Frank Acevedo and LatinFest ICT.)

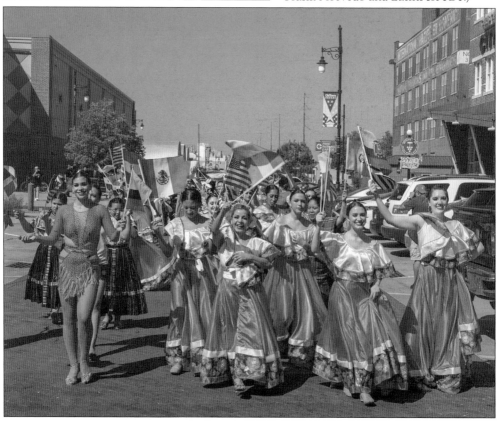

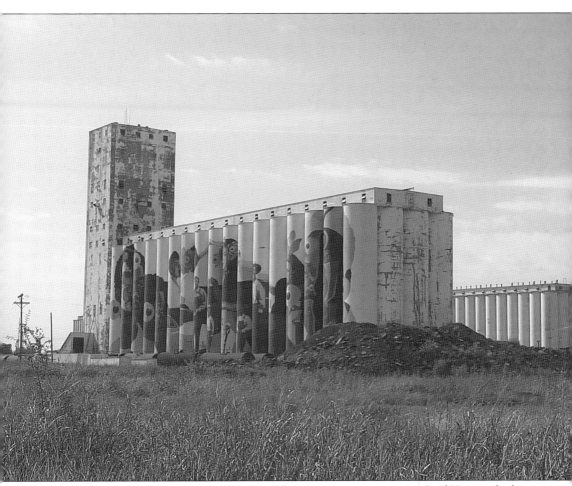

Local artist Armando Minjarez was the founder of the community organization Seed House, which worked to support the North End. His best-known project, however, is one of the world's largest outdoor murals on the side of the old Pillsbury grain elevator that overlooks the site of the former El Huarache neighborhood. It honors the area's Mexican American and African American stories.

BIBLIOGRAPHY

Abdinnour, Sue, Jay M. Price, and David Hughes "Del Norte Meets Little Saigon: Ethnic Entrepreneurship on Broadway Avenue in Wichita, Kansas." *Enterprise & Society* 18.3 (September 2017): 632–677.

Benitez, Carolyn. *El Huarache: A Photographic Look Back at One of Wichita's First Mexican Barrios.* Exhibit booklet published in connection with the El Huarache Project, 2006.

Cárdenas, Gilberto, ed. *La Causa: Civil Rights, Social Justice and the Struggle for Equality in the Midwest.* Houston, TX: Arte Público Press, 2004.

Franco, Hector. "The Mexican People in the State of Kansas." MA thesis, University of Wichita, 1950.

García, Juan Ramón. *Mexicans in the Midwest: 1900–1932.* Tucson, AZ: University of Arizona Press, 1996.

Johnson, Kenneth F. "Wichita's Hispanics: Tensions, Concerns, and the Migrant Stream." MA thesis, Wichita State University, 1985.

Martínez, Rubén O. *Latinos in the Midwest.* East Lansing, MI: Michigan State University Press, 2011.

Millard, Ann V. and Jorge Chapa. *Apple Pie and Enchiladas: Latino Newcomers in the Rural Midwest.* Austin, TX: University of Texas Press, 2004.

Romero, Ray. *The Other Side of the Tracks: The Story about One of the First Mexican-Americans to Play in the National Football League.* Self-published, c. 2010.

Sáenz, Rogelio, and María Cristina Morales. *Latinos in the United States: Diversity and Change.* Cambridge, UK: Polity Press, 2015.

Sheaks, John. *Larry Reder and John Sheaks: Entrepreneurs?: A Memoir.* Self-published, 1999.

Smith, Michael. "Beyond the Borderlands: Mexican Labor in the Central Plains." *Great Plains Quarterly* 1 (1981): 239–251.

Valerio-Jiménez, Omar, Santiago Vaquera-Vásquez, and Claire F. Fox, eds. *The Latina/o Midwest Reader.* Champaign, IL: University of Illinois Press, 2017.

Vargas, Zaragosa. *Proletarians of the North: A History of Mexican Industrial Workers in Detroit and the Midwest, 1917–1933.* Berkeley, CA: University of California Press, 1999.

Winston, Bryan. "Mexican Corridors: Migration and Community Formation in the Central United States, 1900 to 1950." PhD dissertation, St. Louis University, 2019.

————. "Mapping the Mexican Midwest." mappingthemexicanmidwest.bryanwinston.org.

ABOUT THE ORGANIZATION

Mexican American children are raised to not brag about themselves or boast about their family's accomplishments. This means that sharing stories and history outside of family gatherings feels presumptuous. Questions about migration, work, and military service often result in phrases like, "oh, it was no big deal," or "we were just living our lives." Sadly, as the first generation of Mexican Americans of Wichita aged and passed, their stories and recollections passed with them.

That is why projects like that of Carolyn Benitez to document El Huarache were so important in the 2000s. Today, the materials collected in that event are housed at Wichita State University's Department of Special Collections. In recent years, a new effort to collect stories and images has emerged to include events such as the one pictured here at the North End Urban Arts Festival. Here, Anita Mendoza explains the project in front of a large map of the North End decorated in the style of a Día de los Muertos altar.

These activities led to the creation of the North End Historical Society, founded in 2019. Its mission is to make the invisible visible, to bring to light the contributions that Mexican Americans and those in the North End have made to this city. The organization planned for a series of collecting events, including a portable display to take to scanning events. Funded by Humanities Kansas, this project was called Somos de Wichita ("We are Wichitans"). Then COVID-19 hit. Unable to meet in person, the organization launched a Facebook page that has over 1,300 members and has allowed families to share photographs, identify people in old images, and reconnect. The hope is that this book will continue this sharing for years to come.

For more information on the Somos de Wichita project, see somos.wichita.edu.

For the North End Wichita Historical Society, visit facebook.com/groups/1339757216133400.

Discover Thousands of Local History Books
Featuring Millions of Vintage Images

Arcadia Publishing, the leading local history publisher in the United States, is committed to making history accessible and meaningful through publishing books that celebrate and preserve the heritage of America's people and places.

Find more books like this at
www.arcadiapublishing.com

Search for your hometown history, your old stomping grounds, and even your favorite sports team.